WOMEN
ARTISTS

ART ESSENTIALS

WOMEN
ARTISTS

—

FLAVIA
FRIGERI

—

 Thames & Hudson

CONTENTS

6 **INTRODUCTION**

**Breaking Ground
(born between 1550 and 1850)**

10 Lavinia Fontana (1552–1614)

12 Artemisia Gentileschi (1593–c.1652)

16 Clara Peeters (1607–21)

20 Rosalba Carriera (1675–1757)

21 Angelica Kauffman (1741–1807)

26 Élisabeth-Louise Vigée Le Brun (1755–1842)

28 Julia Margaret Cameron (1815–79)

32 Rosa Bonheur (1822–99)

34 Berthe Morisot (1841–95)

38 Mary Cassatt (1844–1926)

**Pioneers of the Avant-Garde
(born between 1860 and 1899)**

44 Hilma af Klint (1862–1944)

46 Paula Modersohn-Becker (1876–1907)

50 Gabriele Münter (1877–1962)

52 Vanessa Bell (1879–1961)

54 Sonia Delaunay (1885–1979)

56 Georgia O'Keeffe (1887–1986)

60 Hannah Höch (1889–1978)

62 Lyubov Popova (1889–1924)

64 Tina Modotti (1896–1942)

66 Benedetta Cappa Marinetti (1897–1977)

70 Tamara de Lempicka (1898–1980)

72 Louise Nevelson (1899–1988)

**Triumphs and Tribulations
(born between 1900 and 1925)**

76 Alice Neel (1900–84)

80 Barbara Hepworth (1903–75)

82 Frida Kahlo (1907–54)

84 Maria Helena Vieira da Silva (1908–92)

86 Louise Bourgeois (1911–2010)

90 Gego (1912–94)

94 Agnes Martin (1912–2004)

96 Amrita Sher-Gil (1913–41)

100 Leonora Carrington (1917–2011)
102 Carol Rama (1918–2015)
104 Joan Mitchell (1925–92)

**Challenging Stereotypes
(born between 1926 and 1940)**

108 Alina Szapocznikow (1926–73)
110 Helen Frankenthaler (1928–2011)
112 Yayoi Kusama (b.1929)
114 Niki de Saint Phalle (1930–2002)
116 Magdalena Abakanowicz (1930–2017)
118 Yoko Ono (b.1933)
120 Sheila Hicks (b.1934)
122 Eva Hesse (1936–70)
126 Joan Jonas (b.1936)
128 Judy Chicago (b.1939)
130 Carolee Schneemann (b.1939)

**Contemporary Views
(born between 1942 and 1985)**

134 Anna Maria Maiolino (b.1942)
136 Graciela Iturbide (b.1943)
140 Martha Rosler (b.1943)
142 Marina Abramović (b.1946)
144 Ana Mendieta (1948–85)
146 Cindy Sherman (b.1954)
150 Francesca Woodman (1958–81)
154 Olga Chernysheva (b.1962)
156 Rachel Whiteread (b.1963)
158 Tracey Emin (b.1963)
160 Lynette Yiadom-Boakye (b.1977)
162 Amalia Pica (b.1978)
164 Guerrilla Girls (founded 1985)

166 **Timeline**
168 **Glossary**
172 **Further reading**
173 **Index of artists**
175 **Picture acknowledgements**

INTRODUCTION

Women have traditionally been among art history's favourite objects of representation. As the ultimate emblems of beauty they have been endlessly depicted, and yet their role as producers of art has constantly been subordinated to that of their male peers. Astonished by the lack of recognition suffered by female artists, the American art historian Linda Nochlin asked in 1971: 'Why have there been no great women artists?' Nochlin's timely question expressed a sense of urgency shared by a critical tide of female artists, art historians and critics.

Up to that point the history of art had been dominated by male artists, but this did not mean that there had not been any great women artists. Quite the contrary: women had long been active and working as hard if not harder than their male peers. Their art, however, was more difficult to find. This is especially true of the medieval, Renaissance and Baroque periods when art was almost entirely a male preserve: women were often forced to work in anonymity or take on male pseudonyms. Their work in studios run by

male artists was given little or no credit. As the Flemish artist Clara Peeters reminded us, with the hidden self-portraits in her still lifes, women demanded to be seen (pages 16–19).

Althought the situation has improved, in 1989 the feminist collective known as the Guerrilla Girls demanded, 'Do women have to be naked to get into the Met. Museum?' (page 164). Women and their naked bodies were seen across museum displays; their work as art-makers, however, still remained greatly underacknowledged.

Taking as a starting point the Italian Mannerist painter Lavinia Fontana, this survey will show how women artists went from being objects of passive contemplation to active makers. The focus here is on more than fifty women artists, active from the sixteenth century to the present day, working across media and touching on varying themes. The aim of this broad selection is to give the reader a general understanding of role of women in the history of art, as well as an appreciation of the lives and work of these remarkable female artists.

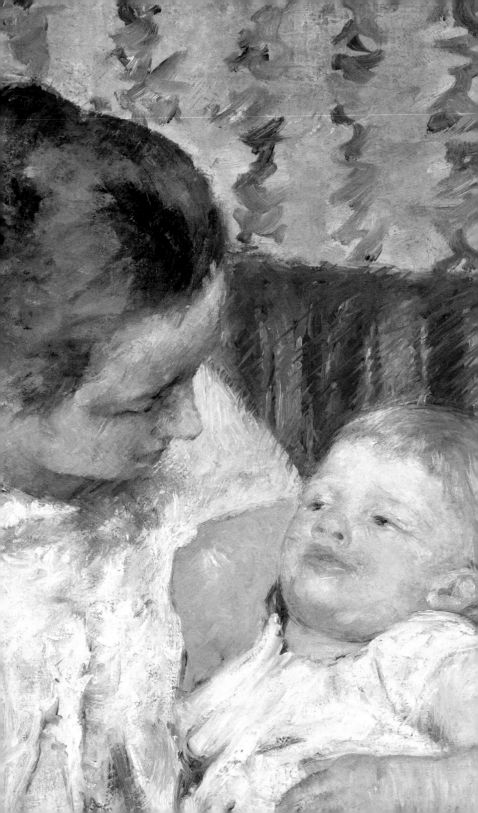

BREAKING GROUND

artists born between 1550 and 1850

-

**You will find the spirit of Caesar
in the soul of this woman**

-

Artemisia Gentileschi

LAVINIA FONTANA
1552–1614

The Italian Mannerist painter Lavinia Fontana is widely regarded as the first woman artist to forge an independent artistic career. Her father, Prospero Fontana, was a leading painter in Bologna, where Lavinia was born. From an early age Fontana cultivated her passion for art and was exposed to the work of the painters Raphael and Parmigianino, while also benefitting from her father's attentive training.

One of Fontana's patrons once remarked: 'This excellent Painter, to say the truth, in every way prevails above the condition of her sex and is a most remarkable person.' Fontana was a very rare exception in the Mannerist landscape. She was a prolific portraitist and achieved reasonable success with her public and private commissions. Her altarpieces for churches in Rome and Bologna gave her a recognition usually reserved for male artists only. Today many of her works are in a frail condition, but the painting *Portrait of Bianca degli Utili Maselli and Six of Her Children* (c.1600) vividly illustrates Fontana's pictorial qualities (opposite). A portrait of the noblewoman Bianca degli Utili with her daughter and five sons is most remarkable for the meticulous detailing of the hairdos and richly embroidered clothes. Fontana strived to capture here the elegance of the family as well as the tenderness and intimacy of their relationship. Fontana died in Rome in 1614. She left behind what is considered to be the largest body of work by any woman artist active before 1700.

Lavinia Fontana
Portrait of Bianca degli Utili Maselli in an Interior Holding a Dog and Surrounded by Six of Her Children, c.1600
Oil on canvas, 99 x 133.5 cm (39 x 52½ in.)
Private collection

The two boys on the far right are shown holding a pen and an inkpot and a medallion with a figure of a knight. These objects are believed to allude to their future professions.

OTHER KEY WORKS
Noli Me Tangere, 1581, Galleria degli Uffizi, Florence, Italy
Queen Luisa of France Presenting Francis I, Her Son, to St Francis of Paola, 1590, Pinacoteca Nazionale, Bologna, Italy
Venus Sucking Cupid, 1610s, The State Hermitage Museum, St Petersburg, Russia
Minerva in the Act of Dressing, 1613, Galleria Borghese, Rome, Italy

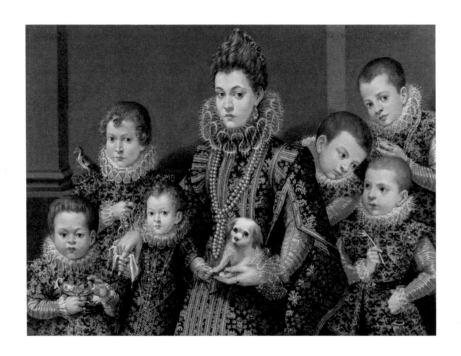

KEY EVENTS

1577 – Fontana marries the artist Paolo Zappi, who painted the draperies in her works; together they have eleven children, only three of whom outlive Fontana.

1589 – The artist is commissioned to paint a public altarpiece of *The Holy Family and St John* for San Lorenzo de El Escorial in Madrid, for which she receives a lavish payment of 1,000 ducats.

ARTEMISIA GENTILESCHI
1593 – c.1652

To this day Artemisia Gentileschi is widely acclaimed as the leading female artist of the Baroque period (c.1600 –1750), characterized by its grandeur and its sense of the dramatic. She substantially contributed to the art of her time. Like Fontana, she was the daughter of a renowned artist, but her background was comparatively humble. To ensure that his daughter was properly trained, Orazio Gentileschi enlisted the help of his friend and collaborator Agostino Tassi. The apprenticeship under Tassi, however, had a tragic consequence when the master made sexual advances on the young Artemisia. Failing to keep his promise of marriage, Tassi was then accused by Orazio of rape. The trial proved to be emotionally distressing for Artemisia who was publicly humiliated with her reputation tainted. As a result, she was forced to leave Rome.

Shortly after the end of the trial, Gentileschi married the Florentine artist Pietro Stiattesi in 1611 and together they moved to Florence. It was here that she made one of her most renowned works, *Judith Beheading Holofernes* (c.1620; Galleria degli Uffizi, Florence, Italy). In keeping with Gentileschi's preference for biblical and mythological heroines, this painting gives a woman a central role, with Judith slaying King Holofernes. *Susanna and the Elders* (1610; opposite) is similarly centred on a strong female character. Rejecting the lascivious old men, Susanna is depicted in a realistic style that is typical of Gentileschi's work. The psychological drama of both compositions is greatly enhanced by the stark contrasts of light and dark (*chiaroscuro*) and the emphatic postures. In both these paintings Gentileschi adopted the style of the Italian painter Caravaggio, twenty-two years her senior, known for his dramatic use of *chiaroscuro*.

Artemisia Gentileschi
Susanna and the Elders,
1610
Oil on canvas, 178 x 125 cm (70⅛ x 49¼ in.)
Schloss Weissenstein, Schönbornsche Kunstsammlungen, Pommersfelden

Particularly striking to contemporary audiences was Gentileschi's ability to portray the tenderness and innocence of Susanna coming out of the bath, as opposed to the lascivious and lustful gaze of the two Elders looking down from above.

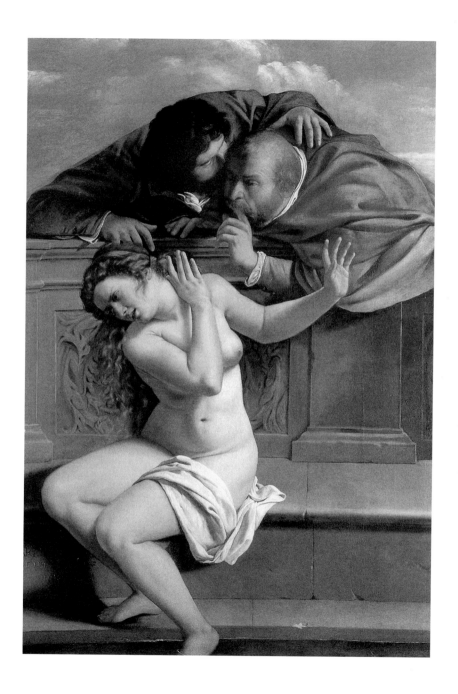

In 1620 Gentileschi moved back to Rome where she remained until 1630. Thereafter, she settled in Naples and left only once to help her father complete the decoration of the Queen's House in Greenwich, London. During her brief English sojourn (1638–c.1641), she painted *Self-Portrait as the Allegory of Painting (La Pittura*; c.1638–9), which entered Charles I's collection. The protagonist of this work is a semi-idealized personification of art, traditionally identified as Artemisia herself. Holding a brush in one hand and a palette in the other, the allegory of painting is skilfully rendered despite the challenging pose of the figure. Artemisia's determination to assert her role as a professional female artist can be seen as a precedent for the struggles experienced by subsequent generations of women artists. In a letter to her patron Don Antonio Ruffo di Calabria, Gentileschi remarked, 'As long as I live, I will have control over my being,' and this is precisely the rule by which she lived until the end of her life.

Artemisia Gentileschi
Self-Portrait as the Allegory of Painting (La Pittura), c.1638–9
Oil on canvas, 98.6 x 75.2 cm (38⅞ x 29⅝ in.)
Royal Collection Trust

This allegorical rendering of painting is based on the conventions set by the iconographer Cesare Ripa in his *Iconologia* handbook (1593; illustrated edition 1603), a reference for many artists at the time.

OTHER KEY WORKS

The Penitent Magdalene, c.1619–20, Palazzo Pitti, Florence, Italy
Birth of St John the Baptist, c.1635, Museo del Prado, Madrid, Spain
Esther before Ahasuerus, no date, The Metropolitan Museum of Art, New York, NY, USA

KEY EVENTS

c.1616 – With the backing of powerful patrons and fellow artists, Gentileschi is the first woman to be admitted to Florence's Accademia delle Arti del Disegno (Academy of the Arts of Drawing).

1617 – She is one of several artists employed to decorate the Casa Buonarroti in Florence.

2002 – First the Palazzo Venezia in Rome, and then the Metropolitan Museum of Art in New York, host an exhibition titled 'Orazio and Artemisia Gentileschi: Father and Daughter – Painters in Baroque Italy', which sets the work of Artemisia in dialogue with that of her father, Orazio.

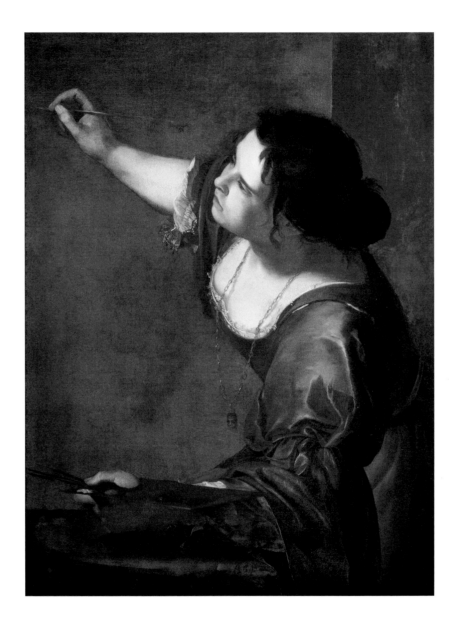

CLARA PEETERS
1607–21

Vases of flowers, intricately decorated goblets, artichokes, fish and shellfish, hand-woven baskets, grapes and jugs are just some of the objects found in Clara Peeters's exquisitely crafted still-life paintings. While a veil of mystery surrounds Peeters's life and artistic upbringing, she is widely regarded as one of the pioneers of Flemish still-life painting.

Peeters's earliest paintings date from 1607 and 1608. The skill with which these meticulous renderings of food and beverages are executed suggests that she benefitted from a training under a master painter – perhaps Osias Beert, a noted still-life painter from Antwerp, was her mentor. Most of Peeters's still-life paintings feature lavishly arranged table settings, enhanced by her adept intepretation of textures and light.

In *Still Life of Fish and Cat* (after 1620; opposite), the terracotta colander is filled to the brim with a pile of painstakingly depicted fish, while a cat clings with pride to his fish prey. Peeters's handling of texture – from the cat's soft fur to the fish scales and the gleaming silver tray, with its multiple reflections – is remarkable. Shining, mirrored surfaces, such as the tray in this work and the pewter flagon in *Still life with Flowers, Gilt Goblet, Almonds, Dried Fruits, Sweets, Biscuits, Wine and a Pewter Flagon* (1611; overleaf), held a particular significance for Peeters. The artist habitually added a twist to her still-life paintings by hiding tiny self-portraits on the reflective surfaces of her motionless objects. Thus by looking carefully, the viewer can catch a glimpse of Peeters in the pewter flagon. The illusionism of the painting is reasserted through these hidden self-portraits, which also challenge the status of women artists at the time. By including her image in the work Peeters's demanded to be seen and her work as an artist to be recognized. Barely forty of Peeters's paintings have survived to this day.

Clara Peeters
Still Life of Fish and Cat, after 1620
Oil on panel, 34.3 x 47 cm, (13½ x 18½ in.)
National Museum of Women in the Arts, Washington, DC

Despite the tranquil nature of the still life, Peeters gives it a sense of drama by alternating brightly lit areas with darker ones.

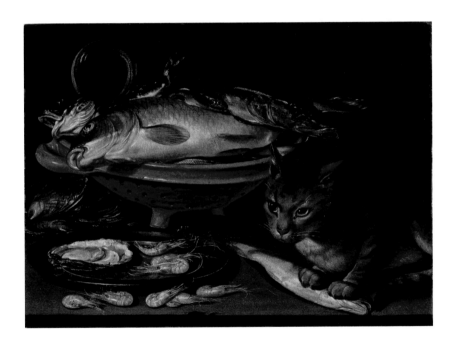

ANOTHER KEY WORK

Still Life with a Vase of Flowers, Goblets and Shells, 1612,
 Staatliche Kunsthalle, Karlsruhe, Germany

KEY EVENTS

31 May 1639 – Aged forty-five Peeters is said to have married
 Hendrick Joossen in Antwerp.

2016 – The 200-year-old Museo del Prado in Madrid organizes a
 solo exhibition to Clara Peeters's work – the first show ever to
 be dedicated to a woman artist in the museum's history.

Clara Peeters
Still life with Flowers,
Gilt Goblet, Almonds,
Dried Fruits, Sweets,
Biscuits, Wine and a
Pewter Flagon, 1611
Oil on panel,
52 x 73 cm
(20½ x 28¾ in.)
Museo del Prado, Madrid

Through the accurate contours and subtle light effects Peeters achieves lifelikeness, with the painstakingly rendered flowers calling to mind early scientific illustrations. Tiny self-portraits can be seen in the pewter flagon.

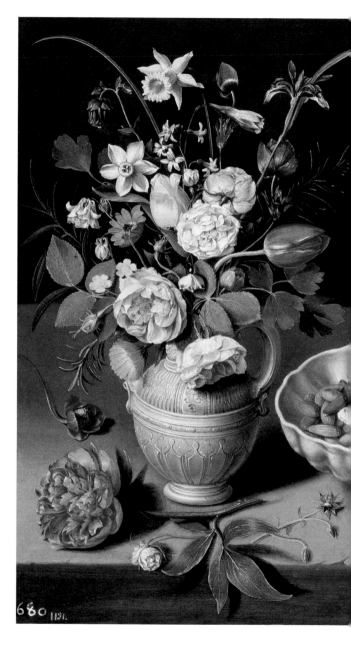

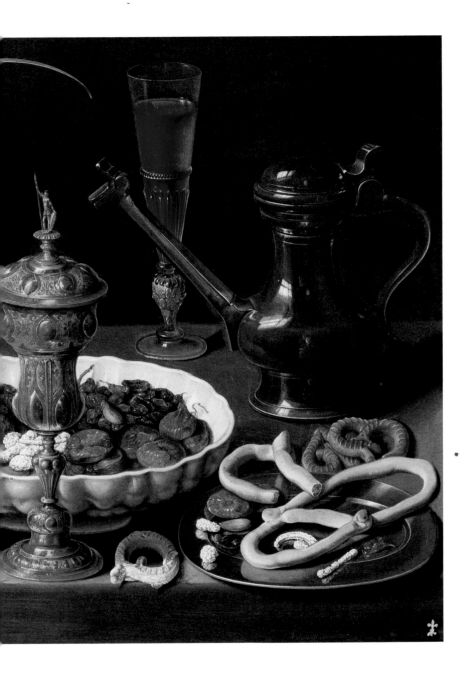

ROSALBA CARRIERA
1675–1757

Rosalba Carriera was an influential miniaturist and pastel-portrait painter. Her works are imbued with the charming and delicate qualities central to the Rococo style, and she is widely credited for her ability to capture the individuality of her sitters.

Born in Venice to a clerk and a lacemaker, Carriera first made a name for herself by painting snuff boxes for Venice's thriving souvenir market. Carriera's treatment of these mementos was so exceptional that she was soon hailed as a talented artist in her own right. She then went on to paint miniatures, which confirmed her success and granted her membership to the prestigious Accademia di San Luca in Rome. By 1703, however, she had started working in what became her most successful medium: pastel portraiture. Carriera's pondered yet gentle portraits capture the glossy and coquettish traits of Rococo painting.

A breakthrough moment in Carriera's career came in 1716 when she made the acquaintance of Parisian banker and art collector Pierre Crozat, who was visiting Italy. Crozat invited Carriera to Paris and introduced her to the Parisian art scene and the royal court, where her works were revered. Here she met the Rococo master Jean-Antoine Watteau; the two artists soon enjoyed long conversations about colour and form. As a tribute to this newfound friendship, Carriera painted a portrait of Watteau, shortly before his death.

Strained by the intense Parisian social life, Carriera returned to Venice in 1721. From then on, with the exception of occasional visits to Modena in 1723 and to Vienna in 1730 to work for Emperor Charles VI, she rarely left Venice and the family house on the Grand Canal, where she lived with her widowed mother and sisters. A rigorous and hard-working artist, Carriera devoted herself almost entirely to her art.

Rosalba Carriera
A Muse, mid-1720s
Pastel on laid blue paper,
31 x 26 cm (12⅛ x 10¼ in.)
J. Paul Getty Museum,
Los Angeles

The subtle blending of the pastels set against the dark background enhances the ethereal quality of this portrait of an unspecified muse. She tilts her head to reveal her porcelain skin caressed by delicate gauze. Carriera was very specific about her pastel chalks and often had her colours custom-made to suit her needs.

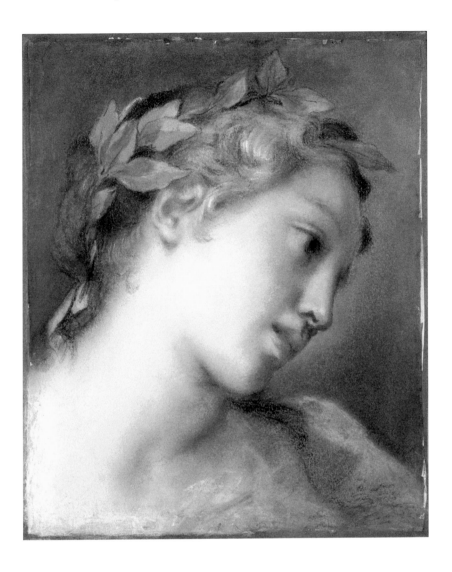

KEY EVENTS

1712 – Carriera first meets Augustus III, Elector of Saxony and
King of Poland. He will amass the largest collection of her work,
including over 150 pastels and miniatures.

1720 – The artist is made an honorary member of the Académie
Royale de la Peinture et de Sculpture in Paris.

ANGELICA KAUFFMAN

1741–1807

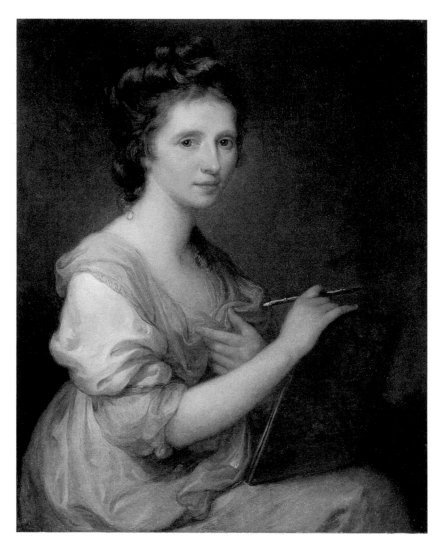

Angelica Kauffman
Angelica Kauffman,
c.1770–75
Oil on canvas, 73.7 ×
61 cm (29 × 24 in.)
National Portrait Gallery,
London

**Kauffman made many
self-portraits during her
lifetime. In this refined
composition the painter
is informally portrayed
at work holding a
sketchbook and a brush.**

Born in Chur (Switzerland), Angelica Kauffman was the daughter of portrait and fresco painter Johann Joseph Kauffman. She was recognized as a child prodigy from a young age. Fluent in four languages and a talented singer, Kauffman assisted her father in church decorations and painted several portraits before reaching the age of fifteen. In 1762 Kauffman travelled to Florence with her father and the following year they moved on to Rome, then the main centre of Neoclassicism. There Kauffman made a name for herself and was able to secure a number of commissions from distinguished travellers visiting the city as part of their Grand Tour, as well as from Roman residents.

What distinguished Kauffman from most women artists of her time was her desire to become a history painter, a genre that was commonly considered the preserve of men. Up to that point, women had tended to paint either portraits or still lifes. In 1765 Kauffman left Rome and travelled to Venice where she met the wife of an English diplomat, who invited her to England. The following year Kauffman parted for the first time from her father and moved to London, where she stayed for the next fifteen years. She quickly established herself and was part of a lively milieu, executing a number of portraits and earning a generous living from her paintings. In London, Kauffman also struck up a close friendship with the leading portrait painter of the time, Sir Joshua Reynolds. The artist championed Kauffman's work and to commemorate their friendship they painted portraits of each other.

Together with fellow artist Mary Moser, Kauffman was one of the founding members of the Royal Academy of Arts in London (1768). This prestigious affiliation is testament to Kauffman's success and ability to establish herself as a history and portrait painter. When the Academy first opened in 1769, four of Kauffman's paintings were on display. In 1778 Kauffman received a further commission from the Academy and was invited to contribute four large allegorical paintings to the newly designed lecture hall. This remains her most successful decorative scheme. Kauffman approached history painting from a woman's perspective: her subjects were mostly female heroines drawn from classical sources. By this point Kauffman had secured a comfortable financial position. Her projects encompassed painting, book illustration, miniature painting and the decoration of Montagu House in Portman Square, Mayfair, London, designed by architect James 'Athenian' Stuart.

In 1781 Kauffman married the Venetian painter Antonio Zucchi and together they left England. Thereafter, she lived mainly in Italy, moving between Venice, Rome and Naples. By now Kauffman had

achieved international fame and was greatly praised. Countless engravings and reproductions based on her works were being made.

After 1795, the Napoleonic campaigns in Italy made it harder for Kauffman to secure foreign commissions and forced her to work at a slower pace. Nevertheless, she remained a central figure in Roman society. As she spoke fluent Italian, French, English and German, her studio was a hub for European aristocrats on the Grand Tour, art dealers, artists and writers, including Johann Wolfgang von Goethe. Kauffman died in Rome in 1807. She left behind an opus of about five hundred works, of which around two hundred are still traceable today, and remains one of Neoclassicism's finest exponents.

OTHER KEY WORKS

Portrait of a Lady, c.1775, Tate, London, UK

Self-portrait with Drawing Pencil and Folder, 1784, Neue Pinakothek, Munich, Germany

Self-portrait Torn Between Music and Painting, 1792, Pushkin Museum of Fine Arts, Moscow, Russia

KEY EVENTS

1775 – Kauffman prevents Nathaniel Hone's painting *The Conjurer* from being displayed in the 'Summer Exhibition' at the Royal Academy. The painting alluded to the rumoured affair between Kauffman and the English painter Sir Joshua Reynolds, her senior by eighteen years.

1807 – The renowned sculptor Antonio Canova organizes Kauffman's funeral ceremony, modelling it on Raphael's death celebrations. The funeral procession includes members of the many academies to which Kauffman belonged.

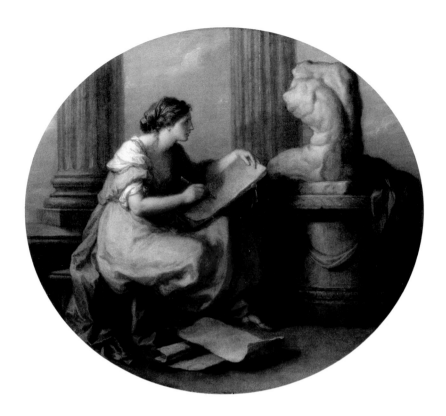

Angelica Kauffman
Design in the ceiling
of the central hall of
the Royal Academy,
1778–80
Oil on canvas,
130 x 150.3 cm
(51⅛ x 59⅛ in.)
Royal Academy of Arts,
London

Design is one of four
large oval ceiling
paintings dedicated to
the Elements of Art that
were commissioned by
the Royal Academy to be
displayed in a new council
chamber. The set – which
also includes *Invention*,
Composition and *Colour*
– was conceived as a
visual representation of
the theories developed
by Reynolds in his
book *Discourses on Art*.
Each canvas featured a
female figure embodying
the different artistic
properties.

ÉLISABETH-LOUISE VIGÉE LE BRUN
1755–1842

Exceptionally talented from a young age, Élisabeth-Louise Vigée Le Brun became a renowned portraitist of the aristocracy. Her success was immense, only comparable to that of her near contemporary Angelica Kauffman. Born in Paris, Vigée Le Brun was educated at a French convent, between the ages of six and eleven. Here she developed an interest in drawing. Her father, Louis Vigée, was a portrait painter and contributed to his daughter's artistic education, introducing her to his artist friends who after his death continued to encourage the young Vigée Le Brun to pursue her studies in painting.

By the age of fifteen, Vigée Le Brun had taken financial charge of her family, supporting her widowed mother and her younger brother. By then her career was taking off and she was painting portraits of members of the international aristocracy, including Count Shuvaloff, the Comtesse de Brionne and the Princesse de Lorraine. Following the success of these early portraits, Vigée Le Brun was invited to Versailles where in 1776 she painted a portrait of the King's brother, known as 'Monsieur'. However, Vigée Le Brun's breakthrough moment came in 1778 when she met the French Queen Marie Antoinette for the first time. Vigée Le Brun soon became the Queen's favourite artist, painting more than twenty portraits of Marie-Antoinette and her children.

In 1776 the artist married the artist and art dealer Jean-Baptiste-Pierre Le Brun, whose gambling addiction was a heavy burden on Vigée Le Brun's finances. At the onset of the French Revolution, Vigée Le Brun was forced to flee Paris and travelled to Italy, where she remained from 1790 to 1793. She then went to Vienna for two years before moving to St Petersburg in 1795, where she spent six years under the patronage of Catherine the Great. In 1801 she returned to Paris, but soon left for London and then Switzerland. Exhausted by this nomadic existence, in 1802, Vigée Le Brun settled in Paris, where she remained for the rest of her life. She left behind about eight hundred paintings, most of which are portraits.

Élisabeth-Louise Vigée Le Brun
Julie Le Brun as Flora, c.1799
Oil on canvas, 129.5 × 97.8 cm (51 × 38½ in.)
Museum of Fine Arts, St Petersburg, Florida

This is a portrait of Vigée Le Brun's daughter, Julie, depicted here as the Roman goddess Flora, traditionally known as the bearer of flowers and spring. Vigée Le Brun tended to flatter her sitters by enhancing their charm and gracefulness.

KEY EVENTS

1783 – Vigée Le Brun becomes a member of the Académie Royale
de la Peinture et de Sculpture in Paris.

1835–7 – Her autobiography, *Souvenirs*, is published, giving
insights into her life and those of her many fashionable sitters.

JULIA MARGARET CAMERON
1815–79

The British photographer Julia Margaret Cameron is one of
the most innovative photographers of the nineteenth century.
Her compositions were renowned for their beautiful staging.
She treated photography as an art form, where the real and the
ideal could come together.

Cameron was born in Calcutta (now Kolkata) in 1815, where her
father James Pattle worked for the British East India Company.
She was sent to France and England to be educated at a young
age. In 1836 during a period of convalescence at the Cape of
Good Hope, Julia Margaret met her future husband, Charles Hay
Cameron, a middle-aged, widowed jurist and businessman based
in Ceylon (now Sri Lanka). The couple were married two years later;
they went on to have six children of their own and adopted six more.
In 1848 the Cameron family moved to London, and thereafter to
Kent, before settling on the Isle of Wight. Here Cameron suffered
a deep depression, caused by her husband's prolonged work
absences in Ceylon. Her oldest daughter gave her a plate camera
in an attempt to cheer her mother up. This gift gave her a new
raison d'être aged forty-eight, and Cameron devoted the rest of
her life to photography.

Cameron converted the coal cellar into a darkroom and turned
the greenhouse into a studio. Although she never ran a commercial
studio, she soon became known for her portraits of friends, family
and servants skilfully staged as biblical, mythological and literary
figures. Children and young adults were among the photographer's
favourite subjects, and were often employed by Cameron for her

Julia Margaret Cameron
The Twilight Hour, 1874
Albumen silver print, 35.1
x 19.4 cm (13⅞ x 7⅝ in.)
J. Paul Getty Museum,
Los Angeles

**The immediacy that
we now attach to
photography was not
common in Cameron's
day. Her photographs
were the product of
lengthy sittings during
which models often
complained of the
physical discomforts that
these entailed.**

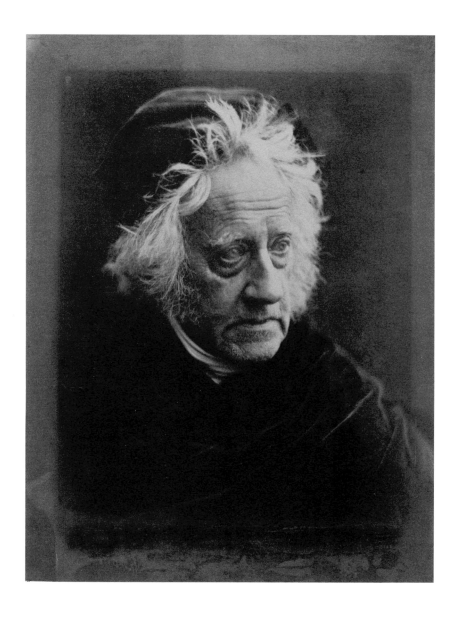

Julia Margaret Cameron
Sir J. F. W. Herschel, 1867
Albumen silver print, 27.9
x 22.7 cm (11 x 8⅞ in.)
J. Paul Getty Museum,
Los Angeles

**Moving in the highest
social and intellectual
circles, Cameron met
the astronomer Sir
John Herschel, who
first introduced her
to photography. They
became lifelong friends
and here Cameron tried
to portray 'faithfully the
greatness of the inner as
well as the features of the
outer man'.**

emphatically choreographed representations of novels and literary works. The drama of her photographs was heightened by the use of low light and prolonged exposure times. Intentionally out of focus and with leftover fingerprints, streaks and scratches, her images reveal her interest in maintaining the presence of her hand on the finished photograph.

Imbued with a melancholic and pensive mood, Cameron's photographs have been compared to contemporary Pre-Raphaelite paintings, especially those of women, such as John Everett Millais's *Ophelia* (1851–2). Cameron turned to her contemporaries and to the art of previous centuries for inspiration. The work of Giotto, Raphael and Michelangelo, which she knew through prints, proved to be particularly influential.

Cameron was personally acquainted with Millais and other members of the Pre-Raphaelite group including Dante Gabriel Rossetti. In 1865 Cameron's first solo exhibition was held in London and thereafter she sold her photographs through the Colnaghi Gallery. In 1875 she moved to Ceylon, where she had difficulty sourcing photographic materials. Cameron died there in 1879, aged sixty-three.

OTHER KEY WORKS
Paul and Virginia, 1864, Victoria and Albert Museum, London, UK
I Wait (Rachel Gurney), 1872, J. Paul Getty Museum, Los Angeles,
 CA, USA

KEY EVENTS
1865 – Eight of Cameron's photographic prints are acquired
 by the Victoria and Albert Museum, which now holds a large
 collection of the photographer's photos and documents.
1875 – Cameron illustrates Alfred Tennyson's poems in *Idylls of
 the King* with her staged photographs.

ROSA BONHEUR
1822–99

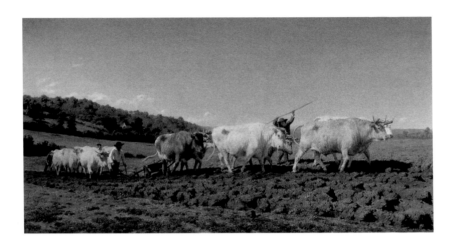

Rosa Bonheur was born in Bordeaux. Widely renowned for her paintings of animals, she led a very extravagant life by French nineteenth-century standards. Bonheur left school at the age of thirteen to help her father, Raymond Bonheur, in his painting workshop. Around this time she also became a regular visitor of the Louvre, sketching the works on view. In 1841 she exhibited for the first time at the famed Salon in Paris. Thereafter, Bonheur's work would be regularly featured at the Salons and, after 1853, she had become so established as a painter that she no longer had to submit her works for jury selection to future exhibitions.

Bonheur's ability to depict animals brought her fame. Her elaborate compositions skilfully portrayed animals in their natural surroundings. From rabbits to cows and horses, Bonheur gave the animal realm a sense of historical monumentality. To accommodate her penchant and need to study animals in situ, the prefect of police granted Bonheur official permission to wear male attire, a rather uncommon style for a woman at the time.

The painting that established Bonheur's global reputation was *The Horse Fair*, first exhibited at the 1853 Salon. The dealer Ernest Gambart purchased this painting and devised a very successful campaign to promote it outside of France. Part of Gambart's strategy was to produce a series of engravings of *The Horse Fair*,

Rosa Bonheur
*Labourage nivernais
(Ploughing in Nivernais)*,
1849
Oil on canvas, 133 x 260
cm (52 x 100 in.)
Musée d'Orsay, Paris

In this work, Bonheur painstakingly renders the different textures, from the ploughed earth to the cows' skin.

making it accessible to a wider audience. Contemporaneously, he arranged for the painting to be shown in London under the patronage of Queen Victoria. *The Horse Fair* was later toured around the United States.

From 1849 to 1860 Bonheur was the director of the École Gratuite de Dessin pour les Jeunes Filles in Paris. In 1860 she moved near Fontainebleau with her companion Nathalie Micas to a château Bonheur had purchased. She built a large workshop for herself and established a thriving community of animals living on the premises, including two lionesses. In 1864 Empress Eugénie paid her a visit and the following year Bonheur was awarded the Grand Cross of the Légion d'Honneur, making her the first woman to be bestowed this distinction. Shortly after Micas's death, Bonheur met the American artist Anna Klumpke, who remained by her side until her death on 25 May 1899.

KEY EVENTS

1832 – From the age of ten Bonheur spends many hours a day drawing animals in the still-wild Bois de Boulogne park in Paris.

1893 – Bonheur's work is featured in the Woman's Building at 'The World's Columbian Exposition' in Chicago.

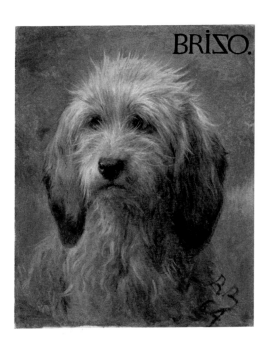

Rosa Bonheur
Brizo, A Shepherd's Dog, 1864
Oil on canvas, 46.1 x 38.4 cm (18⅛ x 15⅛ in.)
Wallace Collection, London

This painting depicts an otterhound, while the name Brizo refers to the Greek goddess, protector of sailors and fishermen.

BERTHE MORISOT
1841–95

'I shall obtain [my independence] only by persevering and by making no secret of my intention of emancipating myself,' Berthe Morisot proclaimed. Born into an upper middle-class family, Morisot embarked on a radical path for a woman at the time by choosing to become a professional artist. Together with Claude Monet, Edgar Degas, Pierre-Auguste Renoir and Mary Cassatt (see pages 38–41), she established herself as an Impressionist painter. Morisot embraced the group's ambition to paint *en plein air* (outdoors), and to represent the immediacy of modern life through fast, loose brushstrokes. Impressionists adamantly wanted to break away from the hierarchies and the arbitrariness of the official Salon system and to establish their own independent exhibitions. Morisot played an instrumental role in the organization of Impressionist displays and took part in seven out of eight shows.

Morisot was, and remains, best known for her paintings of women. Languidly posed, oscillating between melancholia and tenderness, her models embody the spirit of late nineteenth-century middle-class society in France.

The Cradle (1872; opposite) is one of Morisot's most significant paintings. It depicts Morisot's sister Edma Pontillon in front of the cradle of her daughter Blanche, born on 23 December 1871. Exhausted by the fatigue of childbirth, Edma spent a period of convalescence in Paris, where the painting was made. Edma is depicted here as she lovingly, but also apprehensively, leans over the cradle to observe her sleeping baby. Maternal affection is depicted as a discreet but enchanting feeling, a trait that has undoubtedly contributed to *The Cradle*'s lasting success. Stylistically, this work is a remarkable study in transparency. From the veils surrounding the cradle in the foreground to the veiling over the mother's bed, *The Cradle* is an ode to the intimacy of maternity.

Berthe Morisot
The Cradle, 1872
Oil on canvas, 56 ×
46.5 cm (22 × 18¼ in.)
Musée d'Orsay, Paris

When the British royal family visited Paris in July 1938, *The Cradle* was chosen to decorate the reception room of the Minister for Foreign Affairs. Such a choice is testament to the work's centrality in French art and culture. The art historian François Thiébault-Sisson suggested *The Cradle* is 'the poem of a modern woman, created and imagined by a woman'.

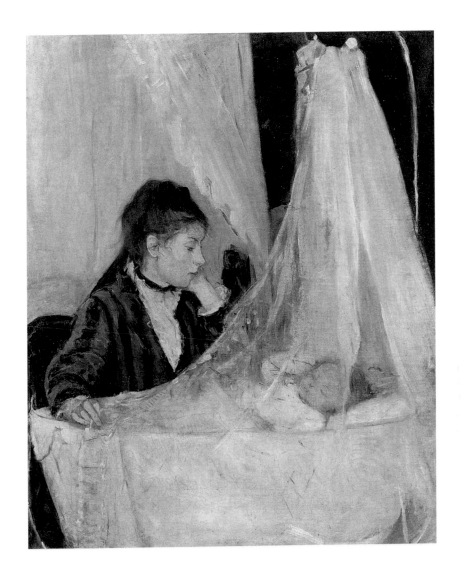

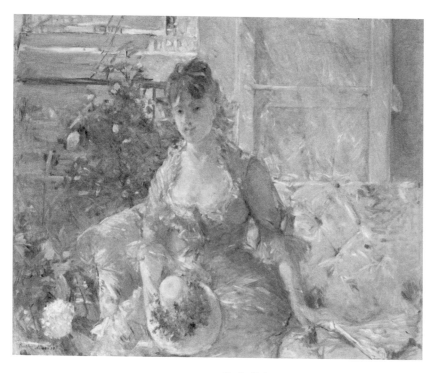

Berthe Morisot
*Young Woman Seated
on a Sofa*, c.1879
Oil on canvas, 80.6 x
99.7 cm (31¾ x 3¼ in.)
The Metropolitan
Museum of Art,
New York

This painting belongs
to a series of portraits
devoted to young
women caught between
melancholy and
expectation. As Morisot
pointed out, these
women are waiting for
the 'positive part of life'
to awake in them.

Young Woman Seated on a Sofa (c.1879; opposite) is exemplary of the artist's ability to capture the light and the sensibility of her sitters. In this painting, the sitter is a young woman elegantly clothed in a light blue dress. She sits on a sofa flanked by a plant in full bloom. The scene is at once poised and vibrant, an effect obtained through its rapid execution and fluid brushstrokes.

OTHER KEY WORKS

The Sisters, 1869, National Gallery of Art, Washington, DC, USA
Paris Seen from the Trocadero, 1872, Santa Barbara Museum of
 Art, Santa Barbara, CA, USA
Woman at her Toilette, 1875–80, Art Institute of Chicago,
 Chicago, IL, USA
A Woman and Child in a Garden, c.1883–4, National Galleries of
 Scotland, Edinburgh, UK

KEY EVENTS

1868 – Morisot meets Édouard Manet. The two artists establish
 a lasting friendship and Morisot sits for eleven of Manet's
 paintings, including *The Balcony* (1868–9), one of his most
 notorious works.

1874 – The first of eight exhibitions of Impressionist painting
 opens in the studio formerly used by the photographer Nadar
 at 35 boulevard des Capucines in Paris. The exhibition features
 works by Claude Monet, Edgar Degas, Pierre-Auguste Renoir,
 Berthe Morisot, Alfred Sisley and Camille Pissarro.

MARY CASSATT
1844–1926

Mary Stevenson Cassatt was born in Pittsburgh, Philadelphia. The fourth of seven children, she spent time in Europe with her family between 1851 and 1855. Cassatt's early travels and her cosmopolitan upbringing eventually contributed to her decision to settle in Paris in 1874, where she became the only American member of the Impressionist group.

In 1877 Edgar Degas invited Cassatt to exhibit with the Impressionists for the first time. As she later explained to the poet Achille Segard (her first biographer), she accepted with joy Degas's invitation: 'At last I could work absolutely independently, without worrying about the opinion of any jury! I had already identified my real teachers. I admired Manet, Courbet and Degas. I hated conventional art. I began to come alive.' From that moment onwards her style was closely aligned with that of the Impressionists. The representation of women was central to Cassatt's work. While Segard noted that she was a 'painter of mothers and their children', he overlooked the overt feminist awareness underpinning Cassatt's work, which focus on women as independent subjects in contemporary society.

Never presented in conventional poses, Cassatt's sitters are often placed off-centre to enhance the realism of the depicted scene. In *Miss Mary Ellison* (c.1880; page 41), Cassatt concentrates on the sitter's pensive state, rather than on her physical appearance. The artist's choice of a loose brushwork over fine detailing is in keeping with the Impressionists. In *Mother about to Wash Her Sleepy Child* (1880; opposite), Cassatt first turns her attention to the theme of motherhood. We see a mother tenderly washing her young child, and as with *Miss Mary Ellison*, the brushstrokes are very expressive and the colours have a delicate pastel quality. It is likely that her brother Alexander's visit to France with his children in the summer of 1880 inspired this intimate scene.

Mary Cassatt
Mother about to Wash her Sleepy Child, 1880
Oil on canvas, 100.3 × 65.7 cm (39½ × 25⅞ in.)
Los Angeles County Museum of Art (LACMA), Los Angeles

The striped wall paper and the child's awkwardly long legs enhances the vertical orientation of this painting.

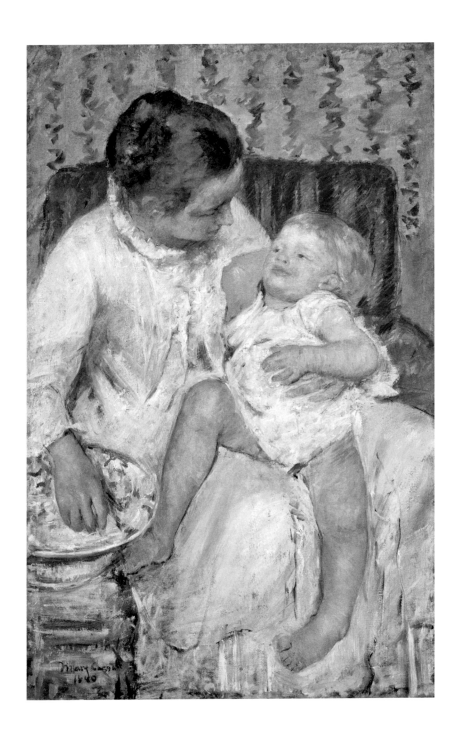

In Cassatt's later work, the influence of Japanese art becomes apparent. With Morisot, the artist paid a visit to an exhibition of Japanese prints at the École des Beaux-Arts in 1890 that had a lasting impact. However, the striped pattern of the wallpaper and the armchair in *Mother about to Wash her Sleepy Child* are already reminiscent of Japanese patterning.

In the mid-1890s the artist purchased the Château de Beaufresne in Mesnil-Théribus, Oise, where she spent the rest of her summers. The onset of blindness forced Cassatt to give up painting in 1914, and in 1926, aged eighty-two, she died at Château de Beaufresne.

Mary Cassatt
Miss Mary Ellison, c.1880
Oil on canvas, 85.5 x
65.1 cm (34 x 25⅝ in.)
National Gallery of Art,
Washington, DC

**Placed behind Miss
Ellison is a mirror,
which allows Cassatt
to amplify the space
of the composition.**

OTHER KEY WORKS

The Tea, c.1880, Museum of Fine Arts, Boston, USA
Children Playing on the Beach, 1884, National Gallery of Art,
 Washington, DC, USA
The Child's Bath, 1893, Art Institute of Chicago, Chicago, IL, USA
Young Mother Sewing, 1900, The Metropolitan Museum of Art, New
 York, NY, USA
Mother and Child with a Rose Scarf, c.1908, The Metropolitan
 Museum of Art, New York, NY, USA

KEY EVENTS

1874 – Cassatt meets Louisine Elder (later Mrs Havemeyer) and
 over the years helps her assemble a large collection of Old
 Masters and nineteenth-century French avant-garde art,
 later bequeathed to the Metropolitan Museum in New York.
1886 – Cassatt and Morisot both take part in the first
 Impressionist exhibition in the United States held at the
 National Academy of Design in New York. This is organized
 by Parisian gallery owner Paul Durand-Ruel.

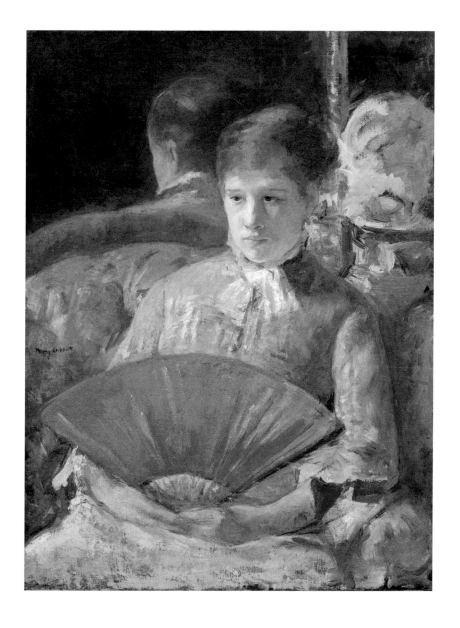

PIONEERS OF THE AVANT-GARDE
artists born between 1860 and 1899

-

**Please know I am quite aware of the hazards.
Women must try to do things as men have tried.
When they fail, their failure must be but
a challenge to others**

-

Amelia Earhart, 1937

HILMA AF KLINT
1862–1944

The Swedish artist Hilma af Klint is considered a pioneer of abstraction. She started working in this style in 1906, before the Russian painters Wassily Kandinsky and Kazimir Malevich. Af Klint, however, is not only an abstract painter; her paintings, texts and notes also reveal her preoccupation with spiritualism.

Af Klint was born in Solna. In 1882 she enrolled at the Royal Academy of Fine Arts there and after graduating, she rented a studio at the Swedish Association of Art. Af Klint maintained a public profile as a landscape and portrait painter, while privately nurturing an interest in Theosophy and mystical theories, having joined the Theosophical Society in 1880. Here she was introduced to ideas about form and colour that would eventually lead her to the abstract style for which she is now best known. In 1896 she joined four other women artists in the creation of the spiritualist group The Five, regularly attending meetings until her death in 1944. Af Klint's will stipulated that none of her paintings, texts or writings could be accessed for twenty years after her death.

Af Klint worked in series. While each series stands out individually, the unifying theme is the desire to reveal what remains invisible to the natural world. One of af Klint's most complex bodies of work is *The Paintings of the Temple* (1906–15). Comprising 193 paintings divided into groups and subgroups, this cycle was inspired by af Klint's search for unity beyond the visible dualities of the world, such a male and female. The series encompasses works touching on the origin of the world and the stages of human growth, among other themes.

Hilma af Klint
Altarbild, nr 1, grupp X, Altarbilder, 1915
Oil and metal sheet on canvas, 237.5 x 179.5 cm
(93½ x 70⅝ in.)
Hilma af Klint Foundation, Stockholm

This painting is one of three large-scale, so-called *Altarpieces*. A triangular colour chart extends here towards a glistening sun, giving the overall impression of a worldly projection into an otherworldly realm.

KEY EVENTS

1908 – Rudolf Steiner, the general secretary of the Theosophical Society in Germany, visits af Klint in her studio in Stockholm.

1986 – Af Klint's work is included in 'The Spiritual in Art: Abstract Painting 1890–1985' in the Los Angeles County Museum, Los Angeles, CA. This occasion marked the first public showing of the artist's work.

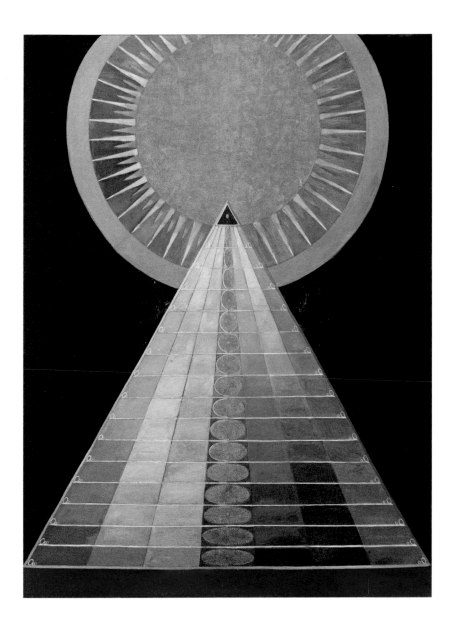

PAULA MODERSOHN-BECKER
1876–1907

Paula Modersohn-Becker is one of Germany's leading Modernist artists. Considered by many as a forerunner of German Expressionism, Modersohn-Becker developed a unique and experimental style based on radical simplification with a keen awareness of colour. She was born to a wealthy family in Dresden. Her family later moved to Bremen where her father, Carl Waldemar Becker, was employed as a building engineer.

Despite being enrolled for teacher training, Becker soon turned her attention to painting. Between 1893 and 1895 she studied with painter Bernhard Wiegandt, and in 1896 she went to Berlin where she attended the Verein der Berliner Künstlerinnen (Association of Berlin Women Artists) art school. She then carried on her studies with the Swedish painter Jeanna Bauck and later perfected her technique in Paris at the École des Beaux-Arts.

Fundamental to Modersohn-Becker's artistic development was the small village of Worpswede, not far from Bremen. This barren and fairly isolated place was host to a community of artists, including painters Fritz Mackensen, Otto Modersohn and Heinrich Vogeler. At one remove from city life, this colony of artists enjoyed painting en plein air and concentrated on the naturalistic depiction of the rugged and atmospheric landscape of Worpswede and its surroundings.

In 1897 Modersohn-Becker visited Worpswede with her family and returned the following year to study under Mackensen. Unlike the rest of the Worpswede colony, she preferred to paint local inhabitants rather than the landscape. Her portraits conveyed the appearance and inner feelings of her models. Modersohn-Becker's style, however, was considered too innovative and distant from the prevailing aesthetic in Worpswede of that time, motivating her to move to Paris in 1899. Nevertheless, in 1901 Becker returned to the small village where she married fellow artist Modersohn.

Paula Modersohn-Becker
Self-Portrait with Amber Necklace, 1906
Oil on canvas, 62.2 x 48.2 cm (24½ x 19 in.)
Freie Hansestadt, Bremen

An image of naivety and blissfulness is conjured here as Modersohn-Becker depicts herself against a backdrop of stylized bushes holding flowers and wearing them on her head.

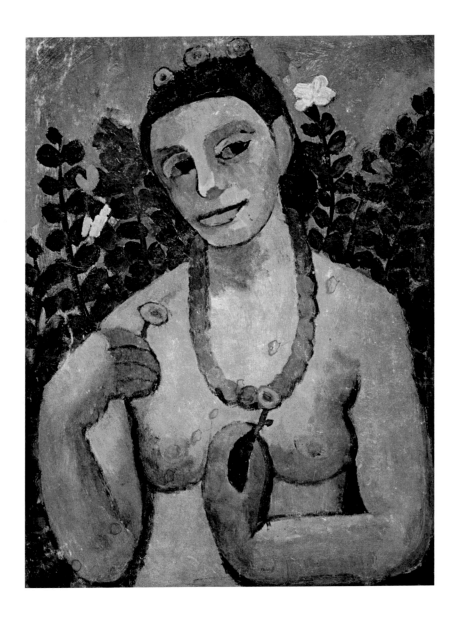

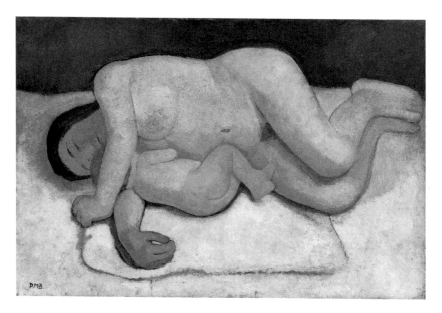

Paula Modersohn-Becker
*Mother and Child
Lying Nude,* 1907
Oil on canvas, 82 x
124.7 cm (32¼ x 49⅛ in.)
Freie Hansestadt,
Bremen

The mother and child
are depicted here as a
single unit mirroring
each other. As with all
of Modersohn-Becker's
maternal figures, this
image too bears a
connection with the
countless representations
of mother and child
found through the
centuries.

While the marriage with Modersohn guaranteed Modersohn-Becker a degree of financial security, it also proved hard to reconcile the union with her ambition to lead an independent career as an artist. Unlike her husband, Modersohn-Becker maintained an interest in artistic developments outside Germany and made frequent trips to Paris. On encountering Paul Cézanne's work at Ambroise Vollard's gallery, she felt an immediate connection with the French artist, whom she described as an older brother. Her enthusiasm for Cézanne was matched towards the end of her life by her interest in Paul Gauguin's work. The latter's influence is perceptible in such works as *Self-portrait with Amber Necklace* (1906; page 47), where the artist portrays herself as an island girl similar to those painted by Gauguin during his extended stay in French Polynesia.

A central theme in Modersohn-Becker's work is motherhood. She came back to this theme repeatedly during her career and returned to it during her pregnancy as well. In 1907 she gave birth to her daughter, Mathilde. The strain of childbirth weakened Modersohn-Becker, who was put on bed rest. She never fully recovered and died of pulmonary embolism less than a month after her daughter's birth.

KEY EVENTS

1900 – Modersohn-Becker meets the novelist and poet Rainer Maria Rilke and the pair establish a close friendship. In memory and as a tribute to his beloved friend, Rilke wrote *Requiem for a Friend* almost a year after Modersohn-Becker's untimely death.

1905 – Modersohn-Becker spends a period in Paris and visits the contemporary art exhibits at the Luxembourg Museum, art galleries, artists' studios (including those of Pierre Bonnard and Auguste Rodin, among others) and saw the Salon des Indépendants.

GABRIELE MÜNTER
1877–1962

As a forerunner of Expressionism and a member of Der Blaue Reiter (The Blue Rider), Gabriele Münter's life and work is often associated with that of her lover and mentor, the Russian avant-garde artist Wassily Kandinsky. Born in Berlin in 1877, Münter studied briefly at a drawing school in Düsseldorf, before travelling to America with her sister. Thereafter she moved to Munich and enrolled at the Phalanx Art School run by Kandinsky.

During painting expeditions with Kandinsky's Phalanx class, Münter and the Russian artist became romantically involved. Kandinsky encouraged Münter to break with naturalistic academic painting and adopt an increasingly simplified and expressive language. Contents gradually gave way to colour, which finally emerged as the dominant force in Münter's compositions. The artist also developed an interest in folk customs, with a particular fascination for glass painting.

In 1909 Münter inherited enough money to purchase what was to become known as the Münterhaus, or by local inhabitants as the Russian House, in Murnau. Finely decorated by Münter herself, the Münterhaus became a hub for the artistic avant-garde. Franz Marc, August Macke, Alexej von Jawlensky and Marianne von Werefkin were regular visitors.

With the outbreak of the First World War in 1914, Münter was separated from Kandinsky who returned to Russia. They were reunited the following year in Stockholm, but that was the last time they met. While Münter patiently awaited her lover's return, he married another woman. The shock for Münter was so great that she spent the next decade wandering between places until she returned to Murnau in 1930 with her new partner, Johannes Eichner. Münter spent the rest of her life at the Münterhaus.

Gabriele Münter
Portrait of Marianne von Werefkin, 1909
Oil on cardboard, 81 x 55 cm (31⅞ x 21⅝ in.)
Städtische Galerie im Lenbachhaus, Munchen

In *Portrait of Marianne von Werefkin* (1909), Münter portrays her artist friend. The bold colours and the sitters' posture convey Von Werefkin's lively temperament. As Münter recalled: 'I painted Werefkina [sic] in 1909 in front of the yellow base course of my house. She was a woman of grand appearance, self-confident, commanding, extravagantly dressed, with a hat as big as a wagon wheel, on which there was room for all sorts of things.' The Blue Rider artists rarely painted portraits as they accorded paramount importance to spiritual and symbolic forms.

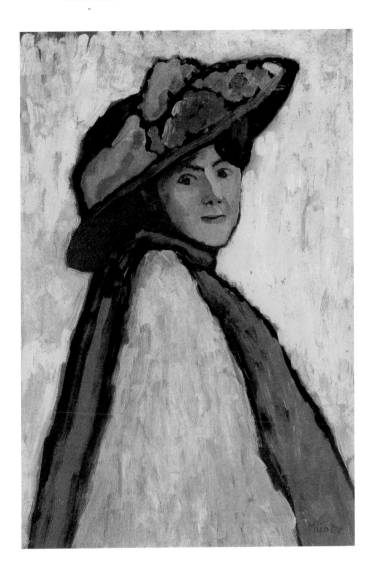

KEY EVENTS

1909 – Münter becomes a member of the Neue
 Künstlervereinigung München (NKVM; New Artists' Association
 Munich). The Association's first exhibition is held in Munich
 and later travels to several German cities.

1930 onwards – Münter guards the paintings Kandinsky had left
 behind at great personal risk. The Nazi regime classified them
 as 'degenerate art'.

VANESSA BELL

1879–1961

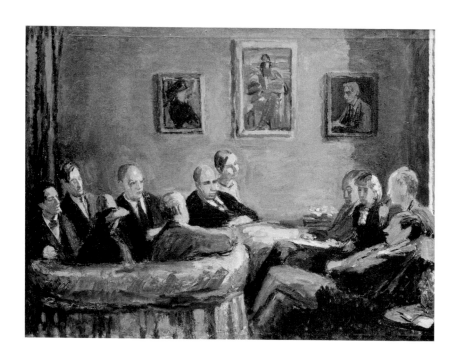

The painter Vanessa Bell was the sister of prominent novelist Virginia Woolf and the great-niece of photographer Julia Margaret Cameron. She grew up in a privileged household in London and after the death of her father, Sir Leslie Stephen, in 1904, she moved with her sister, Virginia, and her brothers, Thoby and Adrian, to 46 Gordon Square. Here they established the Bloomsbury Group, an informal gathering of artists, writers and intellectuals. *The Memoir Club* (c.1943; opposite) celebrates the legacy of the Bloomsbury circle. This collective portrait depicts key associates of the group, including Duncan Grant, Clive Bell and Virginia Woolf's husband, the writer and publisher Leonard Woolf.

In 1911 Vanessa had married the art historian and aesthetician Clive Bell. The marriage did not last and Vanessa entertained a long, unconventional love affair with the artist Duncan Grant. Throughout her career she exhibited widely and could count on the support of leading avant-garde art historian and artist Roger Fry. Her pictorial style consisted of bold colours and flat planes. Integral to Bell's practice was the design of interior decorative schemes. The most famous example is the decoration of her country home, Charleston Farmhouse in Firle, East Sussex, where she lived from 1916 until she died in 1961. In 1980 the eighteenth-century house was transformed into a museum.

Vanessa Bell
The Memoir Club, c.1943
Oil on canvas, 60.8 x
81.6 cm (24 x 32⅛ in.)
National Portrait Gallery,
London

On the wall behind the main figures a series of painted portraits of former members of the Bloomsbury Group can be identified. These include one of Virginia Woolf by Duncan Grant and another of Roger Fry by Vanessa Bell.

OTHER KEY WORKS

Virginia Woolf, 1912, National Portrait Gallery, London, UK
Bathers in a Landscape, 1913, Victoria and Albert Museum, London, UK
Composition, c.1914, The Museum of Modern Art (MoMA), New York, NY, USA
Abstract Painting, c.1914, Tate, London, UK

KEY EVENTS

1912 – Bell takes part in Roger Fry's second 'Post-Impressionist Exhibition' at the Grafton Gallery in London. Participants include Pierre Bonnard, Henri Matisse and Pablo Picasso.
1913–19 – Bell is involved in the decorative arts programme of the Omega Workshops, where she designs furniture, wallpapers, book covers and stage sets.

SONIA DELAUNAY

1885–1979

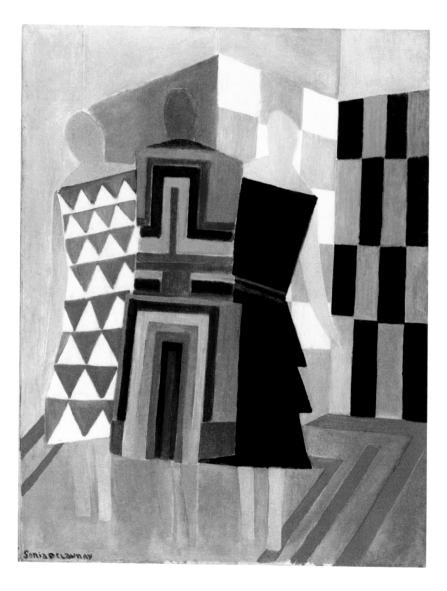

Sonia Delaunay
*Simultaneous Dresses
(Three Women, Forms,
Colours),* 1925
Oil on canvas, 146 x 114
cm (57½ x 44⅞ in.)
Museo Nacional Thyssen-
Bornemisza, Madrid

**The emphasis is placed
here on the dresses, while
the women are reduced
to faceless mannequins.**

Sonia Delaunay, together with her husband, Robert Delaunay, embraced simultaneity, as a form of art and a lifestyle. Simultaneity, as they understood it, was based on an abstract language of colour and contrasts. Through strident combinations, the couple evoked the buzz of the city with its simultaneous and disparate experiences. Unlike her husband, who focused primarily on painting, Delaunay explored simultaneity across different media, from textiles to cars.

Delaunay's penchant for fashion and interior design led her to establish her own textile business, Atelier Simultané. The fabrics' vibrant patterns and bold colours also served as the basis for her fashion designs. Known as 'simultaneous dresses', Delaunay's clothing line spoke to the modern and fashionable woman. Constructed out of bits of fabric of varying sizes, forms and colours, the 'simultaneous dresses' combined the ideals of simultaneous painting with the mobility of ready-to-wear fashion. Delaunay was often seen wearing her own designs to the point that it could be argued that she fashioned herself as a living and breathing work of art.

In the painting *Simultaneous Dresses (Three Women, Forms, Colours)* (1925; opposite), Delaunay presents us with three women, each sporting a different 'simultaneous dress'. A celebration of 'simultaneous clothing', the painting remarkably combines the abstract designs of the dresses and their backdrop with the figurative forms of the three female bodies.

OTHER KEY WORKS

Chanteurs Flamenco (Flamenco Singers, known as *Large Flamenco*), 1915–16, CAM – Calouste Gulbenkian Museum, Lisbon, Portugal
Rythme couleur (Rhythm Colour), 1964, Musée d'Art Moderne de la Ville de Paris, Paris, France

KEY EVENTS

1913 – Delaunay meets the novelist and poet Blaise Cendrars and together they created the first 'simultaneous book'. Her designs complement the 445-line poem-painting *La Prose du Transsibérien et de la petite Jehanne de France.*
1923 – The artist presents 'La Boutique des Modes', her first showcase of textile creations.

GEORGIA O'KEEFFE
1887–1986

Georgia O'Keeffe is famed for her flower paintings. She first turned to this subject matter in 1919 and explored it throughout her career. O'Keeffe's flower paintings, as revealed by *Jimson Weed/White Flower No. 1* (1932; opposite), focus on the transformations of nature. The size of the flower is greatly enhanced and the palette is reduced to a few colours, which strengthen the unity of the composition. O'Keeffe's approach to her flower painting is far from formulaic and each one is treated in a disciplined yet highly individualized manner.

The second of seven children, O'Keeffe was born near Sun Prairie, Wisconsin. She attended the School of the Art Institute of Chicago and later trained at the Art Students League in New York. By 1912 she had begun a two-year job teaching art at a high school in Amarillo, Texas. The year 1917 marked O'Keeffe's artistic breakthrough, with the opening of her first solo exhibition at Alfred Stieglitz's 291 Gallery in New York. Stieglitz soon became her lover, mentor and lifelong companion. The couple were married in 1924, after he had obtained a divorce from his first wife.

Around this time O'Keeffe turned her attention to skyscrapers as a motif for her paintings. Her visibility as an artist was increasing and in 1926 she was invited to give an address at the National Woman's Party Convention in Washington, DC. In 1928, while on vacation with O'Keeffe at Lake George, Stieglitz suffered his first serious heart attack. The following year O'Keeffe visited New Mexico for the first time. Not until after her husband's fatal stroke in 1946 did she make New Mexico her home, permanantly living there from 1949 until the end of her life.

In New Mexico, and in Taos specifically, the artist first came across animal skulls, which she shipped back to New York, so that she could continue to work on a series of paintings prominently

Georgia O'Keeffe
Jimson Weed/White Flower No. 1, 1932
Oil on canvas, 121.9 x 101.6 cm (48 x 40 in.)
Crystal Bridges Museum of American Art, Bentonville

O'Keeffe's interest in flowers was not limited to their depiction; she was also a successful gardener in her own right.

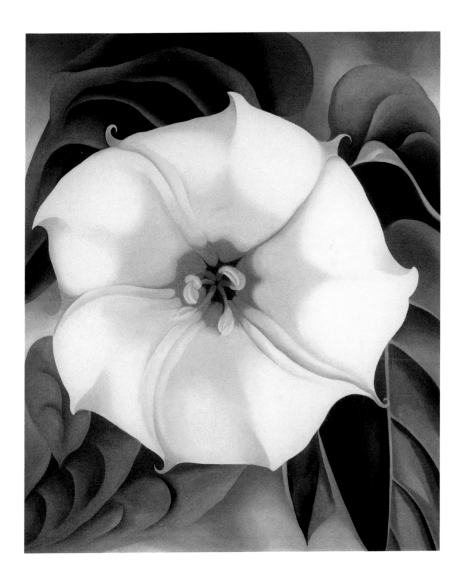

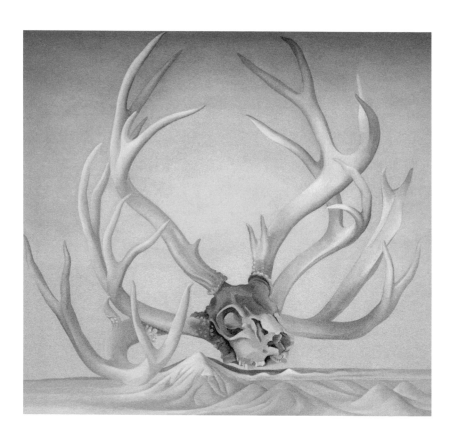

featuring skulls. *From the Faraway, Nearby* (1937; opposite) is one of such paintings. The choice of this quintessentially American West subject played on the highly mythologized feats of American cowboys. For O'Keeffe, nevertheless, these works represented a peculiar relationship between the living and the spiritual realm, rather than overtly celebrating the machismo of Western heroics. As she explained:

Georgia O'Keeffe
From the Faraway,
Nearby, 1937
Oil on canvas, 91.4 x
101.9 cm (36 x 40⅛ in.)
The Metropolitan
Museum of Art, New York

The paintings of animal skulls and bones have been described as a form of 'Southwestern Surrealism' not too distant from René Magritte's suspended forms.

To me they are strangely more living than the animals walking around – hair, eyes and all with their tails twitching. The bones seem to cut sharply to the centre of something that is keenly alive on the desert even though it is vast and empty and untouchable – and knows no kindness with all its beauty.

O'Keeffe's interest in this alluring, but also surreal, myth of the West, reveals she was much more than merely a painter of sexually charged flowers.

OTHER KEY WORKS

Black Mesa Landscape, New Mexico/Out Back of Marie's II, 1930, Georgia O'Keeffe Museum, Santa Fe, NM, USA

Cow's Skull: Red, White, and Blue, 1931, The Metropolitan Museum of Art, New York, NY, USA

Sky with Flat White Cloud, 1962, National Gallery of Art, Washington, DC, USA

KEY EVENTS

1936 – O'Keeffe is commissioned to do a large flower painting for Elizabeth Arden's New York salon.

1939 – The artist is invited by Dole Pineapple Company to visit Hawaii, where she produces a series of tropical landscapes.

HANNAH HÖCH
1889–1978

Hannah Höch stood her ground in the male-dominated Berlin Dada group with her bitingly critical, inquisitive and satirical collages and photomontages. Born in Gotha, Germany, to an upper middle-class family, Höch left home in 1912 to settle in Berlin. There in 1915 she met the Austrian painter Raoul Hausmann, who soon became her lover, companion and colleague. They were both immersed in Berlin's avant-garde art scene. Around this time Höch obtained a job at Ullstein Press, where she made embroidery and lace designs for women's magazines. This job gave her access to a pool of publications, which she raided for images to use in her photomontages.

In 1920 Höch took part in the First International Dada Fair held at Dr Otto Burchard's gallery in Berlin. Höch presented here her most famous photomontage, the large and irreverent *Cut with the Kitchen Knife Dada through the Last Weimar Beer-Belly Cultural Epoch of Germany* (1919–20; opposite). The composition rejects the primacy of a male-centred culture by metaphorically empowering the female characters with a kitchen knife called Dada. Significantly, Germany had granted universal suffrage to its citizens in 1919. The domestic realm, to which women had been traditionally relegated, is replaced here by a new public awareness experienced by the women depicted in the photomontage.

In 1929 Höch left Germany and moved to Holland to live with the Dutch poet Mathilda (Til) Burgman, whom she had met in 1926. At this time the artist adopted a less political, more narrative approach to her compositions. When she returned to Berlin in 1935, Höch was confronted with a starkly different social and political landscape. The National Socialists had risen to power and Höch kept a low profile, moving to a little house in Heiligensee on the outskirts of the city. Thereafter she led an austere and isolated life, until the Allied troops liberated Germany in 1945. In the post-war years Höch's art became increasingly abstract, while also dealing with the rise of consumerism and the mass media. She died in Berlin in 1978.

Hannah Höch
Cut with the Kitchen Knife Dada through the Beer-Belly of the Weimar Republic, 1919–20
Collage of pasted papers, 90 x 144 cm (35⅜ x 56¾ in.)
Nationalgalerie, Staatliche Museen zu Berlin, Berlin

A triumphant celebration of modern woman's empowerment, this photomontage makes extensive use of the wheel as a symbol for change and transience. Dancers, athletes, actresses and artists –women were rising to prominence. Höch hones in on the fact that they were gradually gaining the right to vote in the lower right corner of the photomontage, where she includes a map of the countries in which women could, or soon would be able to, vote.

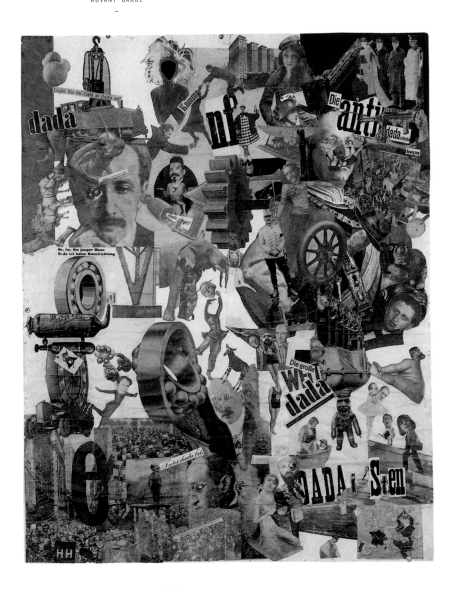

KEY EVENTS

1957 – The launch of Sputnik (the first space capsule to orbit the
earth) has a great impact on Höch, who collects articles and
images of this event.

1976 – A large retrospective of Höch's work opens at the Musée
d'Art Moderne de la Ville de Paris and the Berlin Nationalgalerie,
Staatliche Museen Preussischer Kulturbesitz.

LYUBOV POPOVA

1889–1924

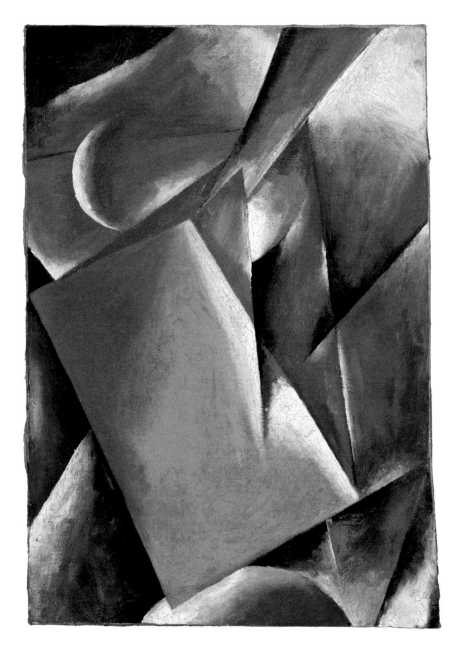

Lyubov Popova
Architectonic Painting,
1917
Oil on canvas, 83.8 x 61.6
x 5 cm (33 x 24¼ x 2 in.)
including frame
Los Angeles County
Museum of Art
(LACMA), Los Angeles

**This painting belongs
to Popova's 'painterly
architectonics'.
Structured around a
series of intersecting
planes, it explores
space through colour
and rhythm.**

Lyubov Popova was born near Moscow. She graduated from the
Arseniev Gymnasium and studied art with Stanislav Zhukovsky.
Between 1909 and 1911 she travelled to Kiev and Novgorod where
she visited Russian churches and viewed historical icons. At this
time Popova also visited Italy, where she was introduced to early
Renaissance art. In 1912 she joined Vladimir Tatlin and other Russian
artists in a Moscow studio known as the Tower. That same year she
left Russia for Paris, where she studied under Henri Le Fauconnier,
among others. The following year she returned to Russia, before
leaving again for France and Italy.

During her Parisian stay Popova mastered the Cubist idiom and
was introduced to Futurism. Popova's own work merged the faceted
planes of Cubism with the dynamism of Futurism. Increasingly,
however, the artist shied away from Cubo-Futurism in favour of
abstract forms, inspired by Kazimir Malevich's Supremus Group,
which she joined in 1916. From then on, Popova's work was primarily
preoccupied with colour, texture and rhythm, in what she called her
'painterly architectonics'. The aesthetic and compositional elements
underpinning these works were readapted by Popova in her textile
and theatre designs of the 1920s.

From 1921 the artist turned away from painting to devote
herself almost exclusively to the production of utilitarian objects
and designs. These included textiles, dresses, books, porcelain,
costumes and theatre sets. Popova died in Moscow in 1924.

OTHER KEY WORKS

Composition with Figures, 1913, The State Tretyakov Gallery,
Moscow, Russia
Birsk, 1916, Solomon R. Guggenheim Museum, New York, NY, USA
Painterly Architectonics, 1917, Kovalenko Art Museum,
Krasnodar, Russia

KEY EVENTS

1914–16 – Popova participates in many influential exhibitions,
including the two 'Jack of Diamonds' exhibitions in Moscow and
'0.10: The Last Futurist Exhibition' in St Petersburg.
1921 – The artist takes part in the avant-garde exhibition '5 x 5
= 25' in Moscow.

TINA MODOTTI
1896–1942

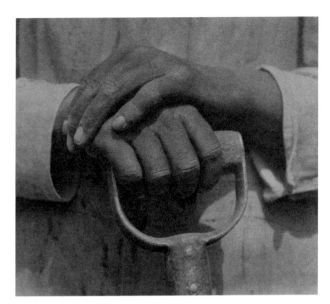

Tina Modotti
Hands Resting on Tool,
1927
Palladium print, 19.7 x
21.6 cm (7¾ x 8½ in.)
J. Paul Getty Museum,
Los Angeles

**In this image Modotti
portrays the hardships
of labour by
photographing a worker
resting his dusty hands
on the tool of his trade.
By 1927 Modotti's
work had become
more politicized as a
result of her affiliation
with the Mexican
Communist Party.**

Actor, photographer and political activist, Tina Modotti was born in
Udine, Italy. In 1913 Modotti joined her father, Guiseppe, who
had migrated to the United States in search of work, settling in
San Francisco in 1907. She found work as a seamstress in the
I. Magnin department store. Beautiful and charismatic, Modotti was
first offered work as a store model and then invited to perform as
an actor. Around this time she met her future husband, writer and
artist Roubaix de l'Abrie Richey (Robo). In 1919 they moved to Los
Angeles, where Modotti was given minor roles in silent films. The
liveliness of the local artistic and intellectual milieu dazzled Modotti
and Robo who befriended the photographer Edward Weston.

Modotti's meeting with Weston led to an affair. Disillustioned,
Robo left for Mexico hoping to organize an exhibition of Californian
photographers. However, shortly after his arrival in Mexico City, he
contracted smallpox; he died a few days after Modotti arrived to be
at his bedside. Soon after, she had to deal with the loss of her father
as well. Meanwhile her relationship with Weston was thriving, and in
1923 they jointly decided to relocate to Mexico.

With Weston's mentorship Modotti's career as a photographer blossomed. Mexico and its people were at the core of Modotti's photographs. In particular, she depicted daily struggles and revolutionary politics. Weston left Mexico and Modotti became romantically involved with the Cuban revolutionary leader Julio Antonio Mella, who was assassinated while walking home with Modotti. The police tried to implicate the artist but she was quickly discharged. As Modotti became increasingly involved in the Communist cause, she gave up photography. After periods of deportation and escape between Germany, Russia and Spain, she returned to Mexico in 1939. Aged only forty-five, she died in a taxi, having had a heart attack when returning home from a party.

KEY EVENTS

1929 – Modotti's first solo show opens at the National University, in which she asserted the political nature of her output.

1932 – Modotti's photographs probably influenced Sergei Eisenstein's film *Que Viva Mexico!* The two met in Mosco, where Modotti had moved with the Communist agent Vittorio Vidali.

Tina Modotti
Open Doors, Mexico City, 1925
Palladium print, 24.1 × 13.7 cm (9½ × 5⅜ in.)
J. Paul Getty Museum, Los Angeles

This photograph was taken in the last home that Modotti and Weston shared in Mexico City. Their place had become a meeting point for leading artists and intellectuals, including Frida Kahlo, Diego Rivera and D. H. Lawrence, among others. Here she focuses on the geometry of the architectural elements within their living space.

BENEDETTA CAPPA MARINETTI
1897–1977

Benedetta Cappa Marinetti was one of the most significant artists associated with Futurism. The movement, founded by Benedetta's husband, Filippo Tommaso Marinetti, in 1909, was largely based on the idealization of speed and dynamism, and the rejection of the past. It embraced modern life, especially the city and its means of transport. Futurism was notoriously a male-centred movement hostile to women. Women were scorned and love and marriage torn apart in a number of Futurist manifestoes (many of which were penned by Marinetti). Nevertheless, he established a sentimental bond with the young Benedetta Cappa in 1918.

Cappa Marinetti turned to painting in the aftermath of the First World War. She met the much older Marinetti through her teacher, the Futurist painter Giacomo Balla. Her romantic attachment to Marinetti coincided with the so-called second phase of Futurism. Lasting until the early 1940s, the second phase aspired to capture the thrill of air travel and Cappa Marinetti played a key role in defining it with her poems and paintings. In a style known as *aeropittura*, she tried to emulate the effects and height of flight.

One of the most striking examples of Futurist *aeropittura* is Cappa Marinetti's series of panels *Syntheses of Communications* (1933–4; overleaf), a commission for the Central Post Office in Palermo, Sicily, designed by Angelo Mazzoni. She produced five large detachable panels that responded to the theme of modern communications, emphasizing technological advances. Movement is central to all five panels. *Synthesis of Aerial Communications*, for instance, celebrates the power of flight (opposite). The remaining four paintings feature an industrial ship, a soaring metal antenna,

Benedetta Cappa Marinetti
Synthesis of Aerial Communications, 1933–4
Tempera and encaustic on canvas, 320 x 195 cm (126 x 76¾ in.)
Palazzo delle Poste, Palermo

In this work a plane cuts through the clouds, suggesting that communications no longer happen on earth but take place in the sky. The earth is reduced to a tiny conglomerate of private dwellings, while the sky opens up a whole new array of possibilities.

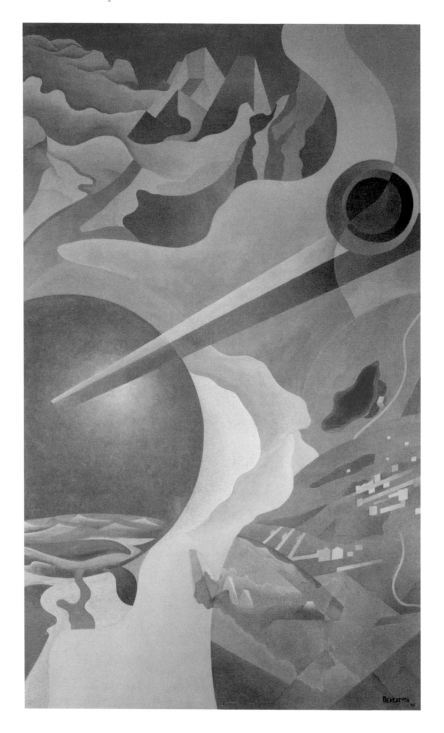

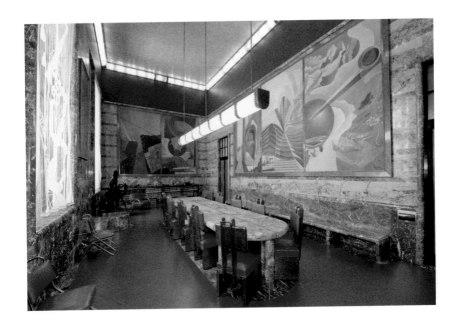

an imposing highway and a set of radio waves expanding across a modern landscape. A common colour scheme unites the five panels, which read as a celebration of a new world dominated by technology and modernization.

In addition to Cappa Marinetti's contribution to *aeropittura*, she was instrumental in developing a new approach to sensory experience. During her initial training as a elementary school teacher, she was impressed by Maria Montessori's teachings on the importance of tactile experience in a child's development. Cappa Marinetti later returned to these ideas and revisited them in the context of Futurism. Together with her husband she developed a set of works, such as *Sudan-Parigi* (1920), designed to be touched rather than seen. Exhausted by the war, Marinetti died in 1944. Cappa Marinetti gave up her practice as an artist and concentrated on the preservation of her husband's legacy for the rest of her life.

Benedetta Cappa Marinetti
Syntheses of Communications (1933–4) in the conference room, Palazzo delle Poste, Palermo

This was one of three mural-sized commissions obtained by the Futurists in the 1930s. Cappa Marinetti was specifically asked to design a decorative scheme for the conference room on the second floor of the building, where her paintings still hang. They celebrate the grandiosity of Fascist state-sponsored public works, which included new highways and bridges.

KEY EVENTS

1931 – Cappa Marinetti was the only woman along with eight men to co-author the *Manifesto dell'aeropittura futurista* (1929), the purpose of which was to incite artists and viewers to leave behind the constraints of the earth and embrace an aerial aesthetic.

c.1939–42 – With the outbreak of the Second World War, Marinetti volunteered to join the troops, while Cappa Marinetti travelled across Italy presenting her politically charged essay 'Women of the Fatherland at War'.

2014 – The Guggenheim Museum in New York manages to secure the first loan of five *Syntheses of Communications* panels from the Palazzo della Poste (Central Post Office) in Palermo, Sicily, for the exhibition 'Italian Futurism, 1909–1944: Reconstructing the Universe'.

TAMARA DE LEMPICKA
1898–1980

A stylish celebrity and a self-confident seductress, Tamara de Lempicka is best known for her paintings depicting the glamour and decadence of the Parisian jet set of the Roaring Twenties. De Lempicka's birth date and birthplace are shrouded in mystery. She was educated in Lausanne and Poland. In 1911 de Lempicka, dressed as a peasant girl with a goose on a leash, charmed her future husband, the young Polish nobleman and lawyer Tadeusz Lempicki, at a masked ball. The couple married in Petrograd in 1916 and their daughter, Marie Christine but nicknamed Kizette, was born that same year. After the Russian Revolution the couple escaped to Paris, where de Lempicka cultivated her artistic talent.

She studied at the Académie Ranson with first Maurice Denis, and then with André Lhote, the only artist whom she ever acknowledged as a mentor. In 1922 de Lempicka exhibited at the Salon d'Automne for the first time, but her family life was starting to deteriorate. Her husband resented de Lempicka's unruly behaviour; she entertained numerous affairs with both men and women, indulged in cocaine, visited night-clubs and blasted the music at full volume in her studio while working. Eventually the couple divorced in 1928 and when Tadeusz remarried in 1932, de Lempicka fell into a depression.

In the 1920s and 1930s de Lempicka was a popular and commercially successful artist. She was much sought after by the American and European elite. Many of de Lempicka's works were exhibited at the prestigious Salon, including *Kizette in Pink* (1926; opposite). By the late 1930s de Lempicka's work was mostly concerned with religious representations of saints and Madonnas. Around this time, she left Paris for Los Angeles with her second husband, Baron Kuffner. They settled in Beverly Hills, where de Lempicka threw lavish parties for hundreds of guests.

De Lempicka's art was disregarded for several decades, until it was rediscovered in the 1970s. In 1978 de Lempicka moved to Cuernavaca, Mexico, where she spent the final years of her life.

Tamara de Lempicka
Kizette in Pink, c.1926
Oil on canvas, 116 x 73 cm (45⅝ x 28¾ in.)
Musée des Beaux-Arts de Nantes, Nantes

Kizette, is portrayed here as a studious young girl dressed in a fashionable summer dress. While the artist never subscribed to any avant-garde movement, the style of *Kizette in Pink* exmplifies de Lempicka's unique engagement with Cubism, whereby she incorporated its flat planes into her figurative work. The position of Kizette's legs recalls Russian icons featuring baby Jesus in a similar cross-legged pose.

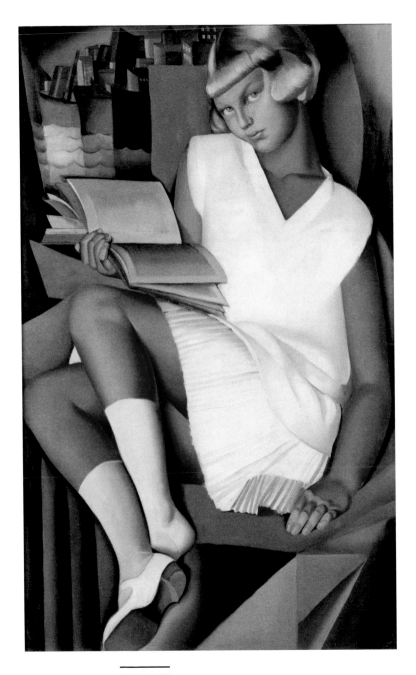

KEY EVENTS

1930 – The artist moves to 7 rue Méchain in Paris; its interiors
were designed by de Lempicka's sister Adrienne.

1972 – The exhibition 'Tamara de Lempicka de 1925 à 1935' at the
Galerie du Luxembourg, Paris, heralds the artist's rediscovery.

LOUISE NEVELSON

1899–1988

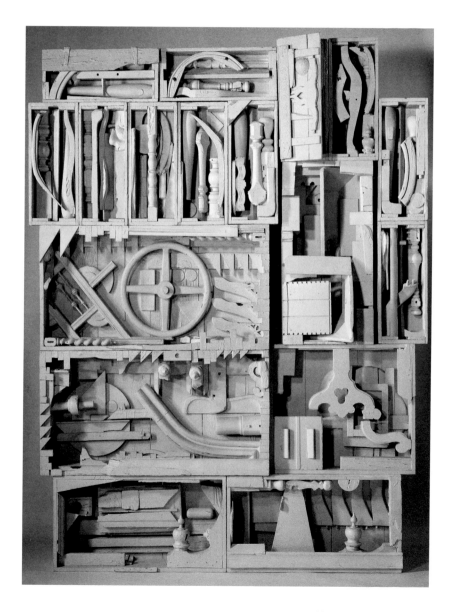

'But above and beyond all it is a Universal love affair for me, and I'm in love with art', stated the pioneer of Modernist sculpture Louise Nevelson. Born in Ukraine, Nevelson sought refuge in the United States from the Russian pogroms, settling there with her family in 1905. She attended the Art Students League in New York between 1929 and 1930, and subsequently travelled to Germany to study art at Hans Hofmann's school in Munich. Nevelson returned to New York in 1933 and a few years later became involved in the Works Progress Administration (WPA), teaching mural painting first and then contributing to the programme as a painter and sculptor. In 1941 she divorced her husband Charles Nevelson.

Best known for her large assemblage works made out of wood, the artist was nevertheless a prolific experimenter, working across different media throughout her career. In 1958 she constructed the ambitious environment *Moon Garden + One*, which consisted of free-standing works and large sculptural walls known as *Sky Cathedrals*. These works were composed of stacked boxes containing found objects and coated in black paint, which lent uniformity to the disparate assemblages.

The following year Nevelson was invited to take part in 'Sixteen Americans', a major contemporary art exhibition held at the Museum of Modern Art in New York. As she later recalled: 'My whole life's been late. Don't forget, dear, that I was fifty-eight in 1958 [sic] when I was in the show at The Museum of Modern Art, *Sixteen Americans*. And they were all much, much younger than I.' Fellow participants included much younger artists like Jasper Johns and Robert Rauschenberg. Nevertheless, Nevelson seized this opportunity to devise another room-sized installation titled *Dawn's Wedding Feast*. Unlike her previous sculptural assemblages, these large quasi-totemic structures were covered in white paint.

During the 1960s she exhibited extensively both in the United States and Europe, including representing the United States at the Venice Biennale in 1962. Nevelson continued experimenting and added aluminium, Plexiglas and steel to her roster of materials. She died at home in New York.

Louise Nevelson
Dawn's Wedding Chapel IV, 1959–60
Wood, painted white,
264.2 x 216.5 x 64.8 cm
(104 x 85¼ x 25½ in.)
Courtesy Pace Gallery, New York

Nevelson hoped that *Dawn's Wedding Feast* would be preserved as a single installation, but without a purchaser she was forced to separate the parts and integrate them into new compositions or, as in the case of *Dawn's Wedding Chapel IV*, sell them as self-standing works. Filled to the brim with found components, each section of *Dawn's Wedding Feast* invited viewers to explore its crevices and layered objects.

KEY EVENTS

1972 – Nevelson gifts to New York her monumental sculpture *Night Presence IV*, currently installed on Park Avenue and East 92nd Street.

1985 – Nevelson is awarded the National Medal of the Arts at the White House in Washington, DC.

TRIUMPHS AND TRIBULATIONS
artists born between 1900 and 1925

-

Of course art has no gender,

but artists do

-

Lucy Lippard, 1973

ALICE NEEL
1900–84

'I am an old-fashioned painter. I do country scenes, city scenes, figures, portraits and still life. Still life is a rest. It's just composing and thinking about lives and colours and often flowers.' Alice Neel, with her penchant for realistic portraiture and soothing still lifes, may well have appeared as an old-fashioned painter to her contemporaries. Active for over five decades, Neel's realism ran against the grain of leading contemporary art movements such as Abstract Expressionism and Minimalism, among others. Nevertheless, her depictions of friends, family, her local community and stars from the art world stand out as powerful representations of humankind. The range of emotions conveyed by Neel's portraits is far-reaching, encompassing maternal love, vulnerability and pensiveness.

Neel's personal life, which often acted as a springboard for her work, was turbulent. In 1925, after graduating from the Philadelphia School of Design for Women (now Moore College of Art and Design), she married the Cuban artist Carlos Enríquez. The couple settled in New York where Neel gave birth to two daughters, one of whom died at a young age. Grief combined with the difficulties of leading an independent career as an artist caused Neel to have a nervous breakdown. In the meantime her husband and surviving daughter had returned to Cuba, leaving her in New York. Thereafter the artist became romantically involved with Kenneth Doolittle, moving in with him in 1932. In a fit of anger, however, Doolittle destroyed hundreds of Neel's drawings. This episode led to the couple's break-up in 1934.

Neel's realist style made her a perfect fit for the public projects promoted by two government bodies, first the Public Works of Art and then the Works Progress Administration, which she counted on for financial and artistic support from 1933 to 1945. During that

Alice Neel
Andy Warhol, 1970
Oil and acrylic on linen,
152.4 x 101.6 cm
(60 x 40 in.)
Whitney Museum of
American Art, New York

Neel's anti-heroic portrayal of Warhol is aimed at revealing the person behind the myth. Sitting against a plain background and with his shirt off, Warhol displays the scars resulting from a violent attack inflicted by the feminist writer Valerie Solanas two years earlier.

Alice Neel
*Linda Nochlin
and Daisy*, 1973
Oil on canvas, 141.9 ×
111.8 cm (55⅞ × 44 in.)
Museum of Fine Arts,
Boston

**In 1973 Neel asked
Nochlin to pose for
a portrait with her
daughter Daisy.** *Linda
Nochlin and Daisy* **should
be read as a celebration
of maternal love and as a
reminder of the struggles
faced by women in
establishing themselves
as independent
individuals. Nochlin
and her daughter Daisy
travelled five times from
Poughkeepsie (where
they were living) to
New York to sit for this
portrait.**

time Neel was briefly involved with Puerto Rican musician José Santiago, with whom she had a son. She later had another son with photographer and filmmaker Sam Brody.

In the 1960s, once her children had grown up, Neel was able to devote more time to painting. In her words: 'The minute I sat in front of a canvas, I was happy. Because it was a world, and I could do as I liked in it.' Sitters posing for Neel were a crucial part of this captivating world and in October 1970, Andy Warhol, one of Pop Art's foremost figures, came to Neel's apartment to sit for a portrait (page 77). In *Andy Warhol*, Neel pictures the artist as a vulnerable man and not as his famed art-world persona. Commenting on Warhol's success, Neel once stated: 'I think he's the greatest advertiser living, not a great portrait painter. From Brillo to portraits, you know. But I think his tomato cans are a great contribution.'

From the start of the 1970s, Neel's work was increasingly recognized, especially by feminist critics and art historians. A great champion of Neel's work was the art historian Linda Nochlin, who included the painter in her seminal exhibition 'Women Artists, 1550–1950' at the Los Angeles County Museum in 1974. A great supporter of the feminist cause, Neel made a number of portraits of key figures within the women's movement, as in Linda *Nochlin and Daisy* (1973; opposite). She died in New York, leaving behind over three thousand portraits.

KEY EVENTS

1959 – Neel appears in the Beat film *Pull My Daisy* along with Gregory Corso, Mark Frank, Allen Ginsberg, Jack Kerouac and Peter Orlovsky.

1979 – Neel is bestowed a lifetime-achievement award from the National Women's Caucus for Art, New York.

BARBARA HEPWORTH
1903–75

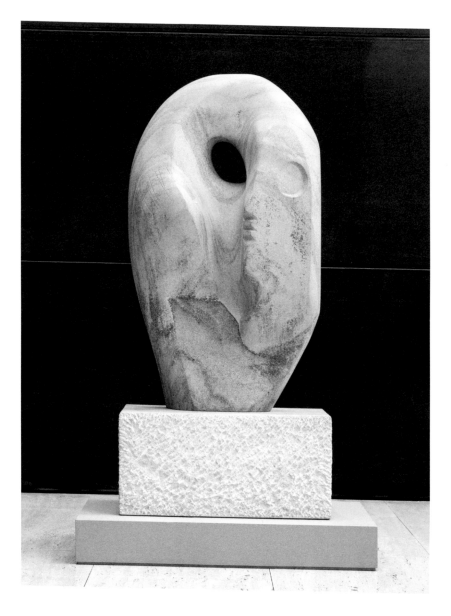

Barbara Hepworth
Biolith, 1948–9
Blue limestone (Ancaster stone), 119.4 cm (47 in.) x 67.3 cm (26½ in.) x 38 cm (15 in), not including marble plinth
Yale Center for British Art, New Haven

Abstract forms played a key role in Hepworth's work. In *Biolith* she presents a biomorphic form carved out of limestone. Form and matter are united here as the shape of the sculpture is derived from the material properties of limestone.

Barbara Hepworth was a British sculptor born in Wakefield, Yorkshire, who is, probably, best known for her proximity to the Modernist artistic community in St Ives, Cornwall. Her work focused on form and abstraction, and related the human figure to nature. Colour and texture were also pivotal. The artist was keenly aware of the specific properties of the materials she used and rather than force form on to a material, she adapted her motifs to the textures with which she was working.

In the 1920s the artist first attended the Leeds School of Art, where she met the sculptor Henry Moore, and then the Royal College of Art, London. In 1925 Hepworth married fellow sculptor John Skeaping in Florence, where they were living at the time. The couple returned to England in 1926 and in 1929, their son Paul was born. Separating from Skeaping in 1931, Hepworth became romantically involved with the painter Ben Nicholson, whom she married in 1938; their triplets, Simon, Rachel and Sarah, were born in 1934.

With Nicholson, Hepworth established links with the European avant-garde, meeting Constantin Brâncuși in Paris and visiting Jean Arp's studio in Meudon. Most significantly they joined the Abstraction-Création Group in Paris, which fostered the primacy of abstraction over figuration. Hepworth and Nicholson were also instrumental in facilitating the stay of fellow artist refugees who came to England, escaping from the totalitarian regimes overtaking Europe in the 1930s.

At the outbreak of the Second World War, Hepworth and Nicholson moved to St Ives in Cornwall, where they were joined by Naum Gabo and his wife. The cramped conditions of their accommodation forced Hepworth to drastically reduce the scale of her work and turn to drawing. In 1942 they moved to a larger place where Hepworth had a studio that enabled her to work on bigger sculptures. In 1949 she bought Trewyn Studio in St Ives, where she lived and worked until her death.

KEY EVENTS

1937 – Publication of the influential *Circle: International Survey of Constructive Art*, designed by Hepworth and Sadie Martin.

1965 – Hepworth is appointed Trustee of the Tate Gallery, a post she retains until 1972. The artist is the first female Trustee.

FRIDA KAHLO
1907–54

A legendary character in her lifetime, Frida Kahlo is one of the best known female artists of all time. Married to the famous muralist Diego Rivera, Kahlo encouraged mythical and enigmatic readings of her life and work. Born in Coyoacán (a suburb of Mexico City) in 1907, Kahlo was involved in a serious road accident aged eighteen. This left her physically vulnerable and led to countless operations, hospitalizations and periods of bed rest.

In 1922 Kahlo met Rivera for the first time. He was working on a mural at the National Preparatory School where she was studying. The two were married in 1929. Their relationship was tumultuous; both had extramarital affairs and in 1939 they divorced, only to remarry in 1940. In 1954 Kahlo died of poor health at La Casa Azul (Blue House) in Coyoacán. A destination in its own right, La Casa Azul is now open to the public and houses the Museo Frida Kahlo.

Most of Kahlo's work focused on her persona. Self-portraits are a core component of her relatively small oeuvre. While her earliest self-representations take Italian Renaissance portraiture as a starting point, her later ones seamlessly merge realism with invention. In her portraits Kahlo fuses her public self with her inner self. In doing so she draws attention to a range of themes, such as her role as a woman, her physical vulnerability and her Mexican identity, as she questions her place in the world. Kahlo's failed attempts to become a mother also take centre stage. Graphically gruesome, these paintings convey the artist's crushed hopes for motherhood.

Despite her friendship with André Breton, Kahlo resisted his attempt to describe her as a Surrealist, stressing her desire to be seen working independently of any contemporary art movement.

Frida Kahlo
Self-Portrait with Monkey, 1938
Oil on masonite, 40.6 x 30.5 cm (16 x 12 in.)
Albright-Knox Art Gallery, Buffalo

Monkeys are a common motif in Kahlo's work. For the artist, who kept monkeys in her garden at La Casa Azul, these pets represented the children she was not able to have.

KEY EVENTS

1936 – Kahlo and Rivera offer support to Republicans fighting the Spanish Civil War.

1943 – Kahlo's work is featured in 'The Exhibition by 31 Women' at Peggy Guggenheim's Art of this Century Gallery in New York.

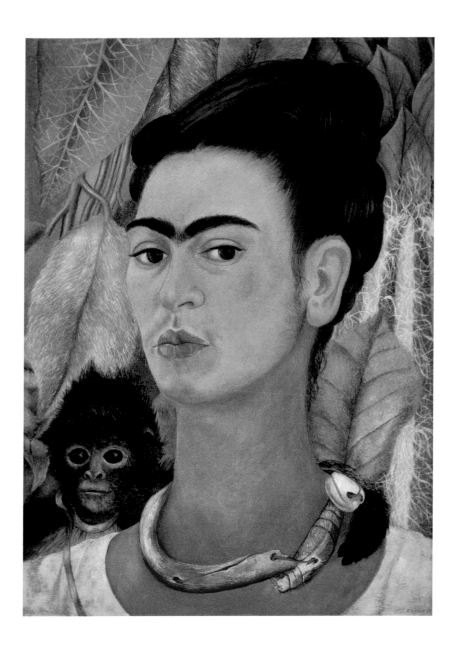

MARIA HELENA VIEIRA DA SILVA
1908–92

Maria Helena Vieira da Silva was born into an affluent family in Lisbon in 1908. Her father died when she was only two years old and her mother, together with an aunt, took care of her upbringing. As she grew up, she was exposed to avant-garde practices like those of the Italian Futurists and the Ballets Russes, while she also developed a taste for music that had a lasting impact on her. She enrolled at the Academia Nacionale de Belas Artes in Lisbon in 1919 and in 1928 she moved to Paris to continue her training at the Académie de la Grande-Chaumière. There Vieira da Silva met her future husband, Árpád Szenès. In 1929 she abandoned sculpture in favour of painting. At the outbreak of the Second World War, Vieira da Silva and Szenès escaped to Portugal before moving on to Rio de Janeiro. They returned to Paris in 1947.

Vieira da Silva's work incorporates a variety of styles and influences. On the one hand, the architectural planes of the cityscape and the decorative geometry of the Hispano-Arabic Azulejo tiles (typical of Portuguese culture) informed her perception of space and its depiction. On the other hand, Vieira da Silva's representation of rhythm and pattern evokes the abstraction of Cubism and Futurism. In 1931 an apparently uneventful episode is said to have had a remarkable impact on the development of Vieira da Silva's style. During a stay in Marseilles with her husband she painted a transporter bridge. From the artist's perspective the bridge's structure compartmentalized space, neatly dividing the sky from the sea. This geometrical partitioning of space was to have a lasting influence on Vieira da Silva who went on to explore a vocabulary based on receding perspectives, interweaving lines and checkerboards.

The artist achieved great fame and recognition in Paris after the Second World War. In the 1950s her paintings increasingly blurred the boundaries between city and nature. The two become one in the artist's jagged planes and irregular grids. Vieira da Silva continued to paint into the late 1980s and was the recipient of numerous awards, including the Commandeur de l'Ordre des Arts et des Lettres in 1962. She died in Paris in 1992.

Maria Helena Vieira da Silva
L'oranger, 1954
Oil paint on canvas, 73 x 92 cm (28¾ x 36¼ in.)
Calouste Gulbelkian Museum, Lisbon

In *L'oranger* space is conveyed through a series of intersecting lines and planes. While the title suggests that this is a depiction of an orange tree, its rendering conveys a sense of movement and vibrancy more akin to a city setting than a tranquil landscape view.

OTHER KEY WORKS

The Optical Machine, 1937, Centre Georges Pompidou, Paris, France

The Corridor, 1950, Tate, London, UK

Aix-en-Provence, 1958, Solomon R. Guggenheim Museum, New York, NY, USA

KEY EVENTS

1933 – Vieira da Silva's first solo exhibition is held at the Galerie Jeanne Bucher in Paris.

1961 – The artist is awarded the First Grand Prize at the São Paulo Biennale.

1966 – She is the first woman to be awarded the French Grand Prix Nationale des Arts.

1968 – The artist's first set of stained-glass windows (made in collaboration with Charles Marq and Brigitte Simon) are placed in the South Chapel of the east wing of St Jacques Church in Reims.

1990 – Creation of the Árpád Szenès – Vieira da Silva Foundation, in Lisbon.

LOUISE BOURGEOIS
1911–2010

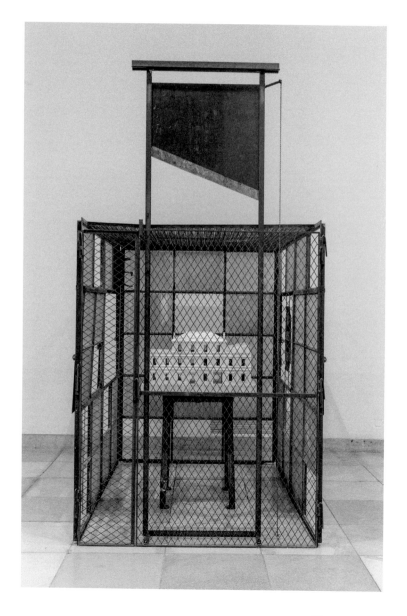

Louise Bourgeois
Cell (Choisy), 1990–93
Marble, metal and glass,
306 x 170.1 x 241.3 cm
(120 ½ x 67 x 95 in.)
Collection Glenstone
Museum, Potomac

Enclosed within the cell is an exact replica of Bourgeois's childhood home in Choisy-le-Roi. It is always caught in a state of suspense, as the guillotine constantly threatens the home but never succeeds in breaking it apart. Bourgeois suggested that the guillotine stood for 'the past being gotten rid of by the present'. In this case the anxiety that Bourgeois was seeking to overcome was tied to her father's relationship with her tutor.

Louise Bourgeois was born in Paris. From a young age she helped her parents in their tapestry restoration workshop. Thanks to this experience, she acquired a technical dexterity with fabrics and sewing that would greatly influence her work as an artist. Bourgeois's childhood was deeply disturbed by the discovery of her father's extramarital affair with her English tutor, Sadie Gordon. Memories of this betrayal, and more generally of her father's dictatorial personality, would resurface throughout Bourgeois's life and work.

Bourgeois subjected the human body to deep scrutiny and feelings such as loneliness, pain, danger, passion and jealousy were brought to the fore. Even though her work engaged with femininity and its trials, the artist staunchly rejected the feminist label. When feminists took her as a role model, she responded by saying that she was not 'interested in being a mother', as her feelings were closer to those of 'a girl who is trying to understand herself'. In light of this response, Bourgeois's work can be seen as an ongoing quest towards self-discovery.

In 1938 Bourgeois married the American art historian Robert Goldwater and moved with him to New York, where she spent the rest of her life. Initially inspired by the architectural heights of city skyscrapers, Bourgeois created a series of sculptures that merged human portraits with architectural attributes. These early works – also known as *Personages* – include *Portrait of Jean-Louis* (1947–9), a portrait of the artist's son. Here Bourgeois appeals to a mixture of abstract and figurative forms, a trait running through much of her later works, too. By the early 1960s the totemic *Personages* were replaced by a series of organically shaped sculptures, now widely recognized as a dominant strand of Bourgeois's sculptural output.

From the 1980s onwards the scale of Bourgeois's work increased drastically, shifting from a relatively intimate scale to a monumental one. The room-sized installation *Cell (Choisy)* (1990–93; opposite) is exemplary of this transition. Born out of an architectural need and a desire to construct a space in which the viewer could walk around, *Cell (Choisy)* calls to mind the restraining space of a prison cell, as well as the connection between blood cells. A space of attraction and imprisonment, *Cell (Choisy)* is specifically concerned with history and memory.

Maman (1999; overleaf) is one of Bourgeois's most renowned works. A monumental sculpture representing a gigantic spider, *Maman* is concerned with motherhood. The spider represents the figure of the mother, who shelters a chest full of marble eggs under her abdomen. Bourgeois left behind an extensive body of work, comprising sculptures, drawings, diaries and prints.

KEY EVENTS

1966 – Bourgeois shows her work in the exhibition 'Eccentric
Abstraction' organized by the critic and curator Lucy Lippard
at Fischbach Gallery in New York. Featured artists include Eva
Hesse and Bruce Nauman, among others.

1982 – Bourgeois's retrospective at the Museum of Modern Art
(MoMA) opens in New York. This was the first retrospective
given to a woman artist at MoMA.

Louise Bourgeois
Maman, 1999
Bronze, 927.1 x 891.5
x 1023.6 cm (365 x
351 x 403 in.)
Private collection

Maman **threatens the
taboo of motherhood,
revealing the ambivalence
of this charged role, which**
**can be simultaneously
nurturing and predatory.
The spider's over life-size
scale is intimidating,
whereas the care with
which she protects her
eggs makes her a symbol
of reassurance.**

GEGO
1912–94

Gego (born Gertrud Louise Goldschmidt) came from a liberal Jewish family in Hamburg. She studied architecture at the University of Stuttgart and graduated in 1938. In 1939, at the outset of the Second World War, Gego was forced to flee Germany and emigrate to Venezuela, where she worked as a freelance architect and industrial designer. From the mid-1950s she turned to art with a particular focus on the relationship between line and space. At the time Venezuela was undergoing a period of rapid urbanization and modernization. Art, and specifically geometric abstraction and kinetic experiments, were hailed as cultural emblems of the country's transformation. While Gego's work shared points of contact with these leading tendencies, she resisted categorization by adopting a largely independent way of working.

Gego's technical skills were extremely versatile and her output includes architecture, drawing, engraving and sculpture. Her training as an architect had a crucial impact on her understanding and exploration of space through light and flexible structures. *Reticulárea (Ambientacion)*, first installed at the Museo de Bellas Artes in Caracas in 1969, is an outstanding example of her *Reticuláreas* series (opposite). Conceived as a large-scale web-like structure, *Reticulárea (Ambientacion)* is made out of anodized aluminium and stainless steel cables of different thicknesses united by a series of joints. The effect is both immersive and overwhelming. The overlapping planes create a discordant geometric effect that gives the work a sense of instability and perpetual flux. Her *Dibujos sin papel* (*Drawings without Paper*; overleaf) also explore the relationship between line and mass. First created in 1976, this series of works is based on the idea of drawing without paper since the drawing is created by the shadow cast on a wall by a suspended metal

Gego
Reticulárea (Ambientacion), 1969
Iron and stainless steel, dimensions variable
Fundación de Museos Nacionales Collection, Caracas

Reticulárea (Ambientacion) has the potential for infinite expansion. It is based on a flexible and variable matrix adaptable to different locations. Through this immersive weave it becomes apparent how Gego's work seeks to engage with space, by creating an experience that constantly changes according to the viewers' individual reactions.

Starting in the 1960s, Gego taught at the School of Architecture of the Universidad Central de Venezuela and the Escuela de Artes Plásticas Cristóbal Rojas. She was instrumental in the foundation of the Instituto de Diseño Neumann in Caracas, where she taught from 1964 to 1977. Throughout her career she was also involved in a series of public projects, which saw the inclusion of sculpture in public buildings, residences and shopping malls.

Gego
Dibujo sin papel 87/25,
1987
Iron and copper, 25.5 x 27 x 0.75 cm (10 x 10 ⅝ x 2/8 in.)
Archivo Fundación Gego, Caracas

The fragility and precariousness of the *Dibujos sin papel* can be viewed as a counterpoint to the precision and refinement of contemporary kinetic works. A discordant woven pattern is contained within a square. By straying away from a clear geometrical pattern, this work oscillates between rigour and disorder.

KEY EVENTS

1960 – Gego's sculpture *Sphere* (1959) enters the collection of the Museum of Modern Art (MoMA) in New York.

1972 – Gego creates *Cuerdas* (Cords), a site-specific nylon and steel sculptural installation for the Parque Central of Caracas.

AGNES MARTIN
1912–2004

In an interview Agnes Martin was once asked: 'What would you like your pictures to convey?' To which she responded: 'I would like them to represent beauty, innocence and happiness; I would like them all to represent that. Exaltation.' This candid, but also uplifting, response captured Martin's aim with her highly refined non-objective paintings. These abstract paintings were spare to the point of absence. By radically reducing her compositions to a few subtle elements, Martin challenged the purpose of painting as a form of representation and invoked a transcendental quality.

Martin left her birth country, Canada, in 1931 to study education in Washington, WA. She later moved to New York to complete her training. While her early works were mainly figurative, featuring landscapes and floral arrangements, she later turned to abstraction, an idiom that she favoured for the rest of her life. Although Martin was living in New York at a very vibrant time artistically, she preferred to live and work alone, with only brief exchanges with her contemporaries. In 1958 she had her first solo show at the Betty Parsons Gallery in New York and since then her art maintained a constant fixation on increasingly reducing the compositional elements. Colours, which prevailed in her earlier works, were cast to one side in favour of white, while grids and lines were made subtler as time went by. Like Georgia O'Keeffe, Martin liked the solitary life offered by New Mexico, where she moved in 1967 and remained in total isolation until the end of her life.

Agnes Martin
Little Sister, 1962
Oil, ink and brass nails on canvas and wood, 25.1 x 24.6 cm (9 ⅞ x 10 in.)
Solomon R. Guggenheim Museum, New York

The grid is a key feature of Martin's work. It is clearly bound, however, by an empty frame that suggests that the grid at the centre of *Little Sister* is limited and is not subject to infinite expansion.

KEY EVENTS

1997 – Martin is awarded the Golden Lion for Contribution to Contemporary Art at the 47th Venice Biennale.

2002 – In celebration of Martin's ninetieth birthday, a large symposium honouring the artist is organized by the University of New Mexico's Harwood Museum of Art.

AMRITA SHER-GIL
1913–41

Amrita Sher-Gil once stated: 'Europe belongs to Picasso, Matisse and Braque and many others. India belongs only to me.' Through this bold statement, Sher-Gil made clear that her art was to India what the triad of men and their many followers had been to Europe: revolutionary. She was pitching herself as a beacon of modern Indian art and this is indeed what Sher-Gil is best known for, both in India and abroad. Of Indian descent, Sher-Gil was born in Budapest, where she spent the first eight years of her life. In 1921 she left Europe with her family and moved to Simla in the north of India. A few years later Sher-Gil's mother insisted that Amrita and her sister set off for Florence to perfect their artistic training. However, the Italian sojourn was short-lived and within five months the two sisters were back in Simla.

In 1927 the arrival of Sher-Gil's uncle Ervin Baktay, marked a turning point in the artist's development. He promptly identified Sher-Gil's artistic talent and encouraged her to pursue it further by studying in Paris. As a result the entire family moved to Paris in 1929, where Sher-Gil was enrolled first at the Académie de la Grande Chaumière and then at the École Nationale des Beaux-Arts. In 1933 she exhibited *Young Girls* (1932) at the Grand Salon and became a member of the prestigious Société Nationale through this picture. The work qualifies as a conversation piece, where the viewer is given access to an intimate *tête-à-tête* between two girls. It showed Amrita's sister, Indira, seated and fully dressed facing the viewer, and a friend – a blonde girl with her long locks clad in a light veiled garment. Sher-Gil captured the sense of mutual affection between the two girls as they chatted away.

In 1934 she returned to India with her parents and settled in Simla, where she embarked on an ambitious plan to introduce modern art to India. As her art developed Sher-Gil rid herself of the academic style that she had learnt in Paris and rediscovered her Indian roots. She endeavoured to deepen her knowledge of Indian

Amrita Sher-Gil
Self Portrait as Tahitian, 1934
Oil on canvas, 90 x 56 cm (35⅜ x 22 in.)
Collection of Navina and Vivan Sundaram

In this self-portrait, Sher-Gil is pictured as a Tahitian girl. The work shows how Sher-Gil was moving away from an academic realist style of painting and adopting increasingly modern forms. The composition is flat and the colours are bold, while the subject matter is clearly indebted to Paul Gauguin's paintings featuring Polynesian girls.

art by studying and travelling extensively. Works like *Group of Three Girls* (1935; opposite) show how she was incorporating the style of Hindu miniatures and local decorative painters, with the synthetic simplicity that she had absorbed from European masters like Paul Gauguin and Amedeo Modigliani. For the artistic renewal of Indian art, she combined indigenous values with a modern European style.

During her time in India she felt intellectually challenged and stimulated by the many acquaintances she made; these included the political leader Jawaharlal Nehru, whom she met in 1937. In 1938 she once again left India for Europe where she married her first cousin Victor Egan. Soon after, the couple returned to India where Egan tried to establish a medical practice and Sher-Gil dedicated herself to painting. Due to a fatal illness Sher-Gil died aged only twenty-eight in 1941. Despite her short-lived career, her work is still hailed as an important landmark in the transition from traditional to contemporary Indian art.

Amrita Sher-Gil
Group of Three Girls, 1935
Oil on Canvas, 73.5 x
99.5 cm (28⅞ x 39⅛ in.)
National Gallery of
Modern Art, New Delhi

Sher-Gil painted this work following her return to India from Europe in 1934. The painting shows three colourfully dressed girls set against a plain sand-coloured background. Their expressions are sombre, revealing a certain degree of resignation towards a future over which they have no control.

KEY EVENTS

1936 – Sher-Gil takes part in an exhibition with the Ukil Brothers at the Taj Mahal Hotel, Bombay (now Mumbai).

1937 – Sher-Gil is awarded a gold medal at the '46th Annual Exhibition of the Bombay Art Society' for her painting *Group of Three Girls* (opposite).

LEONORA CARRINGTON
1917–2011

Leonora Carrington's oeuvre includes both painting and writing. Born into an affluent British family, Carrington studied painting in Amédée Ozefant's London academy. She turned to Surrealism in 1936. Acquainted with the movement via Herbert Read's anthology on the subject, Carrington's interest was further piqued by a visit to the 1936 'International Surrealist Exhibition' in London. The following year (aged twenty) Carrington met painter Max Ernst and moved with him to Saint-Martin-d'Ardèche in the south of France.

With the outbreak of war, Ernst was detained in a camp for foreigners, which contributed towards the nervous breakdown Carrington had in 1940. This episode led to Carrington's internment in a mental asylum in Santander, Spain. Recollections from this experience can be found in her book *En Bas* (*Down Below*), first published in 1945. Painting, as well as writing, offered Carrington an outlet for her delirium. Set in an atmosphere of dream and fantasy, her paintings reveal the inner struggles she experienced.

Between 1941 and 1942 Carrington was based in New York, where she was actively involved with the exiled group of Parisian Surrealists. She then moved to Mexico and made contact with affiliates of the Surrealist movement, such as Remedios Varo and Luis Buñuel. Increasingly Carrington began to incorporate esoteric iconography into her work, which complemented the mythological subject matter of her earlier paintings. In the 1980s Carrington lived in New York and Chicago, before returning to Mexico where she lived until her death.

Leonora Carrington
Self-portrait, c.1937–38
Oil on canvas, 65 x 81.3 cm (26 x 32 in.)
The Metropolitan Museum of Art, New York

This autobiographical painting is imbued with dreamlike symbolic references. The white horse at the back stands in for Carrington's yearning for freedom, while the rocking horse refers to her childhood.

KEY EVENTS

1937 – Carrington assists Max Ernst with the set design for Alfred Jarry's production of *Ubu enchaîné* (*Ubu in Chains*).

1963 – The artist is commissioned to paint a large mural, *The Magic World of the Maya*, at the National Museum of Anthropology in Mexico City, Mexico.

CAROL RAMA
1918–2015

I paint by instinct and I paint out of passion
And anger and violence and sadness
And a certain fetishism
And out of joy and melancholy together
And out of anger especially

Carol Rama
Appassionata, 1943
Watercolour on paper,
34.5 x 18 cm (13⅝ x
7⅛ in.)
Private collection, Turin

The drawings of the *Appassionata* series stem from an autobiographical impulse, as they represent Rama's fears, desires and fascination with the grotesque.

This statement by Carol Rama (born Olga Carolina Rama) reads as a declaration of intent. The many characters and objects that she depicts are the product of her own experience. Her early watercolours – to which *Appassionata* (*Passionate*, 1943; opposite) belongs – are haunted by the fantasies and anxieties, she experienced in her transition to adulthood. Informed by passion, violence and a great deal of emotional upheaval, Rama's output is primarily autobiographical. The visceral nature of these watercolours was deemed to be too extreme for the time and led to the closure and confiscation of her works from her first solo exhibition in 1945 at the Galleria Faber in Turin, Italy.

In 1948 Rama's work was featured in the Venice Biennale for the first time. Soon after she joined the MAC (Concrete Art Movement) and moved on to produce a more detached form of abstraction. Thereafter Rama's work became increasingly tactile and three-dimensional. In the 1970s, for instance, her large canvases accommodated a range of objects, from bicycle tires to worn-out tubes. She later resumed her interest in an intimate form of art that revelled in her own preoccupations and experiences. From the 1990s onwards Rama's work was brought to the attention of an international audience, exposing her to wider public recognition. She died in Turin – the city where she had spent most of her life.

KEY EVENTS

1980 – Rama's work is featured in the seminal all women exhibition 'L'altra metà dell'avanguardia' (The Other Half of the Avant-Garde) in Milan, curated by the art critic Lea Vergine. This inclusion led to the rediscovery of Rama's work.

2003 – Rama is awarded the Golden Lion for Lifetime Achievement at the 50th Venice Biennale.

JOAN MITCHELL
1925–92

Joan Mitchell
La Chatiere, 1960
Oil on canvas, 195 x
147.3 cm (76⅞ x 58 in.)
Collection of the Joan
Mitchell Foundation,
New York

**The painted strokes with
their varying sizes and
trajectories suggest a
push and pull between
opposing forces.**

The second daughter of well-to-do doctor Hebert Mitchell and
poet Marion Strobel, Joan Mitchell was born in 1925 in Chicago.
During high school Mitchell excelled at ice skating and landed
a fourth place at the Junior Women's Division of the US Figure
Skating Championships in 1942. She attended Smith College in
Northampton, Massachussets, first and later transferred to the
School of the Art Institute of Chicago. In 1947 she moved to New
York and lived with Barney Rosset, whom she married in 1949. From
1950 she became closely associated with New York's thriving avant-
garde downtown scene and made the acquaintance of Franz Kline
and Willem de Kooning, among others. She separated from Rosset
in 1951 and participated in the 'Ninth Street Show' organized by
dealer Leo Castelli and the Artists' Club.

In 1955 Mitchell travelled to Paris and met the lyrical abstract
painter Jean-Paul Riopelle, her companion for the next twenty-
five years. Despite mutual love and their influencing each other
artistically and intellectually, the relationship was stormy. Although
Mitchell frequently visited New York and had many exhibitions
there, from 1959 she only painted in France. In 1967, with money
inherited from her mother, Mitchell purchased an estate in
Vétheuil (northwest of Paris), where she lived from 1968 until
her death in 1992.

Mitchell, like Helen Frankenthaler (see pages 110–11), belongs
to the so-called 'second generation' of Abstract Expressionists.
Gestural and highly abstract, her work, like that of her predecessor
Jackson Pollock, is chromatically exciting. Rather than seeking a
conceptual framework for her painting, she concentrated on the
composition and relationship between different elements, most
notably colour and form. Her style changed over the years and her
paintings vary from simple to chaotic.

KEY EVENTS

1957 – Mitchell's work is featured in the group exhibition 'Artists
of the New York School: Second Generation', a landmark between
the first and second generation Abstract Expressionists.

1966 – Mitchell's close friend, the prominent writer and poet
Frank O'Hara, dies in an accident. As a tribute to O'Hara,
Mitchell dedicates the painting *Ode to Joy* (1970–71) to him.

CHALLENGING STEREOTYPES
artists born between 1926 and 1940

-

It was a real shock to see them with their huge paintings, standing there confidently in paint-splattered jeans when their contemporaries were all wearing tweedy classics in the suburbs, terrorized by the 'feminine mystique'. In 1957, avant-garde women artists were a pathetic minority, subjected to every kind of social and critical ridicule

-

Barbara Rose, 1974

ALINA SZAPOCZNIKOW
1926–73

Alina Szapocznikow was born into a Polish Jewish family in Kalisz, Poland, in 1926. As a teenager she was interned in a concentration camp. After the war and having survived the Holocaust, she studied at the School of Arts and Crafts in Prague. From 1947 to 1951 she lived in Paris where she studied at the École des Beaux-Arts. At the end of her studies she returned to Poland, where she quickly rose to prominence thanks to her expressionist sculptural work. Despite her growing fame, she left her native country in 1963 and moved back to France where she settled with the renowned graphic artist Roman Cieslewicz.

Szapocznikow is usually credited for her pioneering use of unconventional materials in her sculptural works. She experimented with contemporary industrial materials such as polyester resin and polyurethane foam, as well as mundane items like newspaper clippings and pantyhose, which she integrated into her assemblages. In terms of subject matter, Szapocznikow's work is primarily concerned with her own body and its fragmentation as a metaphor for loss and memory. With her boldly coloured casts of body parts, she straddled the divide between Surrealism, Nouveau Réalisme and Pop Art. Works like *Lampe-Bouche* (*Illuminated Lips*; 1966; opposite) playfully nod to the dreamlike idiosyncratic nature of Surrealism, while also gesturing to the appropriation of everyday objects in Pop Art. *Lampe-Bouche*, which turns the female body into a utilitarian object, is simultaneously playful and disturbing, visceral and quirky. Szapocznikow died prematurely in 1973.

Alina Szapocznikow
Lampe-Bouche
(*Illuminated Lips*), 1966
Coloured polyester resin,
electrical wiring and
metal, 48 x 16 x 13 cm
(18⅞ x 6¼ x 5⅛ in.)
Galerie Loevenbruck,
Paris/Hauser & Wirth

Lampe-Bouche **is one of a series of lamps made by Szapocznikow featuring a glowing set of red lips on top of a long stem. This work transforms a sensual part of the female body into an object of interior design. With this flirtatious lamp, the artist comments on the proximity of sex and consumer commodities in the 1960s.**

KEY EVENTS

1962 – Szapocznikow takes part in the Carrara Biennale, Italy.

2012 – The travelling exhibition 'Alina Szapocznikow: Sculpture Undone 1955–1972', jointly organized by WIELS Contemporary Art Centre, Brussels and the Museum of Modern Art, Warsaw, brings Szapocznikow's work back into the spotlight.

HELEN FRANKENTHALER
1928–2011

Helen Frankenthaler was born in New York to a wealthy family. She attended the prestigious Dalton School where she studied under the Mexican artist Rufino Tamayo. Thereafter, she completed her education at Bennington College, Vermont, where she was taught by the artist Paul Feely and in July 1950 she took classes with Hans Hoffmann, a leading figure in the genesis of Abstract Expressionism. That same year Adolph Gottlieb chose Frankenthaler's work for inclusion in the exhibition 'Talent' at the Kootz Gallery in New York. Participation in this show sanctioned her ascent within the New York art scene.

From that point onwards, Frankenthaler was recognized as a member of the second generation of Abstract Expressionists along with fellow women artists Elaine de Kooning, Grace Hartigan and Joan Mitchell. In 1958 she married the artist Robert Motherwell and together they travelled extensively, until their divorce thirteen years later. In 1959 Frankenthaler took part in the First Paris Biennale where she was awarded the First Prize.

Frankenthaler once stated: 'Beauty doesn't have to mean a gorgeousness . . . beauty is when it works, it moves me, it's undeniable.' The quest for beauty has been at the core of Frankenthaler's work from the very outset. This is perhaps best expressed by her breakthrough painting *Mountains and Sea* (1952; opposite), where nature is distilled into a series of abstract and floating fields of colour. Imbued with lyricism, this work owes its fame to the subtle, yet revolutionary, technique known as 'stain painting'. This technique proved extremely influential on the development of the Colour Field school of painting and artists Morris Louis and Kenneth Noland readily incorporated it in their work. A tireless experimenter, Frankenthaler explored many techniques and media over the course of her career. Most notoriously she pioneered a resurgence of interest in printmaking.

Helen Frankenthaler
Mountains and Sea, 1952
Oil and charcoal on canvas, 219.4 x 297.8 cm (86⅜ x 117¼ in.)
Helen Frankenthaler Foundation, New York; on extended loan to the National Gallery of Art, Washington, DC

The artist created this work by pouring thinned paint directly on to a piece of unprimed canvas lying on her studio floor. This technique is known as 'stain painting'.

KEY EVENTS

1951– Frankenthaler takes part in the 'Ninth Street Show', organized by artists with the financial backing of the art dealer Leo Castelli. The show featured a number of female Abstract Expressionists including Joan Mitchell, Lee Krasner and Elaine de Kooning.

1985 – Frankenthaler designs the costumes and sets for the Royal Ballet's production *Number Three* at the Royal Opera House in London.

YAYOI KUSAMA
b.1929

Yayoi Kusama has risen to fame with her dot patterns. Her art is multi-faceted, ranging from drawing and painting to sculpture, film, performance and large-scale installations. Kusama was born in Mastumoto, Japan, in 1929. At age ten she was already drawing and painting. As the artist later recalled:

> All I did every day was draw. Images rose up one after another, so fast that I had difficulty capturing them all. And it is the same today, after more than sixty years of drawing and painting. My main intention has always been to record the images before they vanish.

In 1948 Kusama enrolled in the Kyoto Municipal School of Arts and Crafts. However, she quickly became frustrated with the Japanese style that she was taught and turned to the American and European avant-garde. In 1955 she wrote to Georgia O'Keeffe asking the older artist for advice on 'the way to approach this life'. The following year she obtained an American visa and travelled to the United States, settling first in Seattle in 1957 and then New York in 1958. She began experimenting with all over-compositions, which triggered her now famous *Infinity Net* paintings. The surfaces of these works are covered in mesmerizing patterns of dots and nets.

Kusama introduced mirrors in 1965, followed by electric lights in 1966, into her *Infinity Mirrored Room* installations. *Phalli's Field*,

Yayoi Kusama
*Infinity Mirrored Room –
Filled with the Brilliance
of Life*, 2011
Wood, mirror, plastic,
acrylic, LED lights,
aluminium, 300 x 617.5 x
645.5 cm (118⅛ x 243⅛ x
254⅛ in.)
Victoria Miro Gallery,
London and Ota Fine
Arts, Tokyo / Singapore /
Shanghai

**This work, with its
mirrors and dotted lights,
is exemplary of Kusama's
self-construed universe.**

her first *Infinity Mirrored Room*, was presented at the Castellane
Gallery in New York in 1965. In the mid-1960s Kusama also worked
on a series known as *Accumulations*, in which she covered sculptures
or collages with proliferations of sewn phalluses or other objects,
such as macaroni, flowers and stamps.

In keeping with her signature dot motif, in the late 1960s
Kusama staged numerous performances where she covered
nude models with polka dots, referring to this process as 'self-
obliteration'. This included a performance at the Black Gate
Theater in New York in 1967.

In 1973 the artist returned to Japan, where she has since lived
permanently. Through her work, Kusama seeks to overcome the
psychological trauma caused by the hallucinations of endless dots,
flowers and nets she has experienced since her childhood.

KEY EVENTS

1969 – Kusama establishes a fashion label called Kusama Fashion
 Co. Ltd. She opens a boutique on Sixth Avenue in New York,
 where she sells dresses and textiles.
2004 – The artist transforms the Mori Art Museum in Tokyo with
 Dots Obsession installations at her 'KUSAMATRIX' exhibition.

NIKI DE SAINT PHALLE
1930–2002

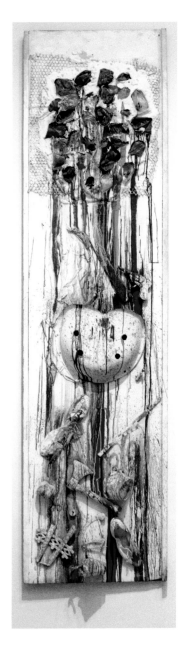

As a child I was unable to identify with my mother or my grandmother. They seemed to be a pretty unhappy bunch. Our home was constrained. A cramped room with little freedom or private life. I didn't want to become what they were, guardians of the hearth; I wanted the outside world to belong to me. I learned at a very early age that MEN HAD POWER, AND THAT IS WHAT I WANTED.

Niki de Saint Phalle
Shooting Painting at the American Embassy, 1961
Paint, plaster, wood, plastic bags, shoe, twine, metal seat, axe, metal can, toy gun, wire mesh, shot pellets and other objects on wood, 244.8 x 65.7 x 21.9 cm (96⅜ x 25⅞ x 8⅝ in.)
Museum of Modern Art (MoMA), New York

Like ripples of blood, the coloured paint streams out from the rifle's barrels.

Thus exclaimed Niki de Saint Phalle, a self-taught artist who rebelled against ruling patriarchal structures. Born to an aristocratic French family, she was brought up between France and the USA, where she received a strict religious education. Despite her rejection of traditional female role models, the artist married at the age of eighteen and soon after became a mother. In 1953 she suffered a nervous breakdown. During her hospitalization, she took up painting.

On 12 February 1961 Saint Phalle choreographed the first of her Happenings. She invited a group of friends to join her in the backyard of her Parisian workshop, where she had set up a series of white plaster reliefs. Hidden behind the white surfaces were bags of coloured paint, which Saint Phalle and her guests exploded with a rifle. This was the beginning of the so-called *Shooting Paintings* or *Tirs* (1961–4). Imbued with parody but also intrinsically violent, Saint Phalle's *Shooting Paintings* laid bare the artist's destructive impulse and granted her membership to the Nouveau Réalistes, of which she was the only female artist. With the *Nanas* series (1965–74), Saint Phalle explored a feminine world made of archetypal female figures. These three-dimensional renderings of colourfully painted voluptuous women set the tone for a new matriarchal age.

KEY EVENTS

1966 – For the exhibition 'Hon – en katedral' at Moderna Museet in Stockholm, Saint Phalle makes a monumental *Nana* (in collaboration with Jean Tinguely and Per Olof Ultvedt). This is placed in the main hall of the museum and visitors are invited to enter through the figure's vagina, which leads to a series of entertainments, comprising a milk bar, an aquarium and a cinema.

1978 – De Saint Phalle starts work on her monumental *Giardino dei Tarocchi* (Tarot Garden) in Tuscany, Italy. Her designs are based on tarot cards.

MAGDALENA ABAKANOWICZ
1930–2017

Magdalena Abakanowicz was born in Falenty near Warsaw, Poland. As a child, she made sculptures with clay, stones and broken china. With the onset of the Second World War, Abakanowicz's family left their country estate and settled in Warsaw, where the artist returned in 1950 to enrol at the Academy of Fine Arts. At the time, Socialist Realism was the state's officially sanctioned style and all artists including Abakanowicz were forced to train in it. Despite the restrictions imposed by Socialist Realism, the artist developed an independent lexicon centred on weaving.

In 1962 she participated in the first Biennale Internationale de la Tapisserie in Lausanne with her *Composition of White Forms*, made from hand-spun and woven thick cotton ropes. This marked the start of Abakanowicz's interest in weaving, which climaxed in the late 1960s with a series of installations based on elaborate woven structures. These works, known as *Abakans* (a self-coined term derived from her surname), were suspended from the ceiling and invited viewers to enter their interior spaces. Made out of a great variety of materials, from horsehair to rope, the *Abakans* shifted the emphasis for the audience from detached observation to tactile engagement. Notwithstanding the prohibitive nature of Communism and its reluctance to let its citizens travel freely, Abakanowicz was able to show her work outside Poland. In 1965, for instance, she won the Gold Medal at the São Paulo Biennial, Brazil, with her tapestries.

Magdalena Abakanowicz
Unrecognized, 2001–2, from the series *Crowd*, a group of 112 figures
Cast iron, each figure: c.210 x 70 x 95 cm (82⅝ x 27½ x 37⅜ in.)
Cytadela Park, Poznań

This large-scale public sculpture is permanently installed on a hill outside Poznań's city centre. This area used to host a nineteenth-century Prussian fort, destroyed during the Second World War. Abakanowicz described her public projects, such as this, as 'spatial experiences'. One of her largest outdoor installations, *Unrecognized* comments on the condition of mankind. These headless bodies walking through the peaceful park convey suffering and a sense of incompletion.

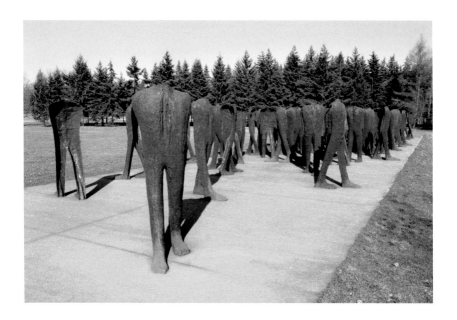

Starting in the mid-1970s Abakanowicz moved away from the *Abakans* and began experimenting with new materials, such as bronze, stone and concrete. At this stage the body and the human figure gained prominence in her work, as exemplified by *Unrecognized* (2001–2; above). Here a crowd of 112 headless iron figures fearlessly stride forward. Abakanowicz died in Warsaw.

OTHER KEY WORKS

Yellow Abakan, 1967–8, The Museum of Modern Art (MoMA),
 New York, NY, USA
Embryology, 1978–80, Tate, London, UK
Standing Figure, 1981, Denver Museum of Art, Denver, CO, USA
Cage, 1981, Museum of Contemporary Art, Chicago, IL, USA

KEY EVENTS

1960 – Abakanowicz's first solo show in Warsaw is cancelled
 as her work is deemed to be too distant from the idealized
 naturalism of Socialist Realism.
1969 – The artist works on the film *Abakany*, with friend and
 Polish film director Jaroslaw Brzozowski, by creating an
 installation of *Abakans* on the sandy Baltic coast beaches.
1974 – The Royal College of Art in London award Abakanowicz the
 title of Doctor at Honoris Causa.

YOKO ONO
b.1933

Yoko Ono is an artist associated with the development of the Fluxus movement and the rise of Conceptual Art. Her artistic contributions include paintings, sculptures, large-scale installations, performances, films and experimental music. Ono's practice is also characterized by a strong penchant for social and political activism. Together with her late husband, John Lennon, Ono embarked on a series of awareness-raising projects. Most noticeably, the couple spent a week in their honeymoon suite protesting against the Vietnam War. Ono's anti-war activism is ongoing and through her WAR IS OVER! campaign she continues to promote world peace.

In the performance *Cut Piece* (1964; opposite), Ono invited the audience to approach her on stage and cut off her clothing. As her clothes fell apart, Ono's vulnerability was unveiled. In a statement concerning this work Ono claimed: 'People went on cutting parts they do not like of me finally there was only the stone remained of me that was in me but they were still not satisfied and wanted to know what it's like in the stone.' The stone acts as a metaphor for Ono's core, namely her body.

By placing the clothes, which traditionally hide and protect the body, under siege, Ono is asking her audience to take on a potentially transgressive role. No longer just passively observing art, the audience is tasked here with making art. They are invited on stage with the artist and are told to perform with her. In doing so, they are made complicit in this act of unveiling, which could refer to the art historical tradition of placing female subjects and their naked bodies on public view. This attitude is clearly shown by earlier works, such as Giorgione's *Sleeping Venus* (c.1510) and Édouard Manet's *Olympia* (1863). Ono's performance needs to be read as a counterpoint to these historical depictions of femininity. While art occupies a feminine realm for Ono, she is not only concerned with gender: her tireless social and political activism continues to be central to her work. Ono lives and works in New York.

Yoko Ono
Cut Piece, 1964
Performance, Yamaichi
Concert Hall, Kyoto
Courtesy Galerie Lelong
& Co.

Cut Piece **was first
performed in the
Yamaichi Concert Hall in
Kyoto in 1964 and later
in Tokyo, New York and
London. As Ono noted,
audience reactions varied
depending on the venue
and country in which the
work was performed.**

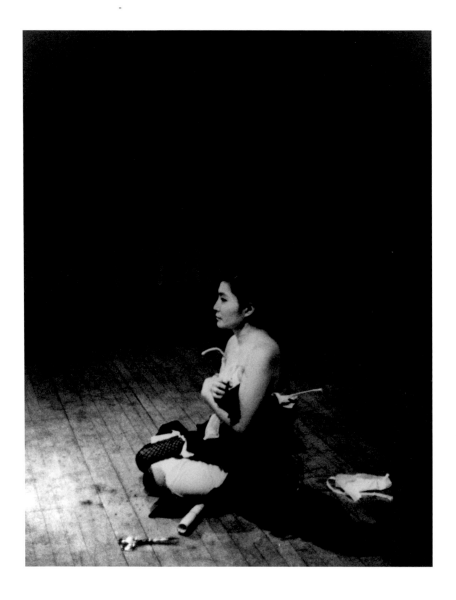

KEY EVENTS

1955 – Ono leaves Sarah Lawrence College, Yonkers, NY, and
 moves to New York City where she meets John Cage, George
 Brecht, George Maciunas and La Monte Young, among others.
 These figures are now all associated with Fluxus and its origins.
2002 – Ono launches a Peace Prize, which is awarded to artists
 living in areas of conflict.

SHEILA HICKS
b.1934

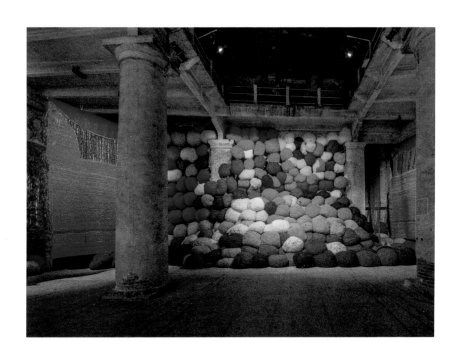

Over six decades Sheila Hicks has explored the artistic potential of fibre, which she discovered while a student at Yale University. There she was taught by leading Modernist artists including the painter Josef Albers, whose sense of colour greatly influenced Hicks. Similarly, architect Louis Kahn helped Hicks to develop an understanding of architectural forms and space. After completing her Bachelor of Fine Arts at Yale, she travelled throughout South America on a Fulbright grant. This was the first of many trips, including five years in Mexico, which introduced Hicks to Pre-Columbian textile art. She met indigenous weavers and studied historical tapestries and techniques. Since then Hicks has devoted her work to the study of fibres and fabric. As she explains:

Sheila Hicks
Escalade Beyond Chromatic Lands, 2016–17
Mixed media, natural and synthetic fibres, cloth, slate, bamboo, Sunbrella fabrics, 600 x 1600 x 400 cm (236¼ x 629⅞ x 157½ in.)
Installation view, Arsenale, 57th Venice Biennale, Venice, 2017

> I became absorbed into the story of what is a tapestry, what is not a tapestry, what is a new tapestry, what is the tapestry that leaves the wall and jumps into space – three-dimensional. And I became a pioneer in the new tapestry movement.

Through the overwhelming array of fibre bales piled against the wall of the Arsenale, one of the exhibition spaces of the Venice Biennale, Hicks creates a powerful visual and tactile experience. The intensity of the coloured-fibre bales draw the viewer into this imposing structure. It challenges the idea of delicacy and intimacy usually associated with tapestry.

Hicks's work, which mostly consists of tapestries and small- and large-scale sculptures made out of fibres, was included in landmark exhibitions of textile art, such as 'Wall Hangings' at the Museum of Modern Art in New York in 1969. Hicks's ambition, however, is not to be classified as a tapestry artist, but rather to build bridges across a range of disciplines, including art, architecture, design and the so-called decorative arts and crafts. As part of this Hicks has created public works that respond to architectural sites, as well as small sculptures conceived on a much more intimate scale – like the *Minimes*, which are small woven works. *Escalade Beyond Chromatic Lands* (2017; opposite) was included in the Pavilion of Colours at the 57th Venice Biennale in 2017. Hicks explained that the starting point for this installation was the crack on the left-side wall of its chosen site. Her aim was for the art to meet and integrate with the pre-existing architectural structure, the Arsenale – one of the established venues for the Venice Biennale.

KEY EVENTS

1969 – Air France commissions Hicks to develop a series of nineteen textile panels for the business-class area of their first fleet of jumbo jets.

2018 – The Centre Pompidou in Paris puts on *'Lignes de Vie'* (Lifelines), a large-scale retrospective surveying sixty years of Hicks's career.

EVA HESSE
1936–70

Eva Hesse was born in Hamburg, Germany. Hesse and her family managed to escape Nazi persecution and relocated to the United States in 1939. They settled in the German Jewish community of Washington Heights. For a short period between 1952 and 1953 Hesse attended the Pratt Institute of Design in New York where she enrolled in an advertising design course. She continued her artistic training at the Art Students League, while also securing a job at *Seventeen* magazine. From 1954 to 1957 Hesse attended the Cooper Union Art School, also in New York, where she was awarded a certificate in design. She then enrolled at the Yale School of Art and Architecture where she studied under Josef Albers, among others. Having obtained her Bachelor of Arts degree from Yale, Hesse moved back to New York where she met her future husband, the sculptor Tom Doyle. The couple married in 1961.

In 1963 Hesse's first solo show opened at Allan Stone Gallery in New York. Around this time she made the acquaintance of critic Lucy Lippard and fellow artists Sol LeWitt, Robert Ryman, Robert Morris and Robert Smithson, among others. In 1964 Hesse and Doyle were invited by the industrialist Friedrich Amhard and his wife, Isabel, to spend a period of time working in Kettwig near Essen in western Germany. The couple extended their stay from six to fifteen months.

In Kettwig Hesse started work on her painted relief sculptures made out of discarded materials found in the disused textile factory that housed her studio. These included cords and electric wiring, which Hesse repurposed in her brightly coloured and abstract textured reliefs, as exemplified by *Legs of a Walking Ball* (1965; opposite). Hesse showed the drawings and reliefs created during her German sojourn in a solo exhibition, 'Eva Hesse: Materialbilder und Zeichnungen' at the Kunsthalle Düsseldorf in 1965.

In 1966 Hesse and Doyle returned to New York, but split up shortly afterwards. The same year Hesse completed one of her most

Eva Hesse
Legs of a Walking Ball, 1965
Varnish, tempera, enamel, cord, metal, papier-câché, unknown modelling compound, particle board and wood, 45.1 x 67 x 14 cm (17¾ x 26⅜ x 5½ in.)
Leeum, Samsung Museum of Art, Seoul

Reliefs, like this one, often corresponded to drawings inspired by the machinery found in Hesse's working space in Kettwig.

important works, *Hang Up* (1966; opposite), which she described in the following terms:

> It was the first time my idea of absurdity of extreme feeling came through . . . The frame is all cord and rope . . . It is extreme and that is why I like it and I don't like it. It's so absurd to have that long thin metal rod coming out of that structure . . . It is the most ridiculous structure that I ever made and that is why it is really good.

Hang Up was comprised of a wall-mounted frame with a steel cable attached to its upper and lower opposing corners. Breaking out of the empty frame, the cable cast a shadow on the back wall. With this work, Hesse trod a fine line between the two-dimensionality of painting and the three-dimensionality of sculpture. *Hang Up* expressed Hesse's interest in Minimalism and its penchant for seriality, repetition and grids. The artist included some of these aspects into her practice. However, what best defines Hesse's work is her use of unconventional materials, including latex, papier-câché (masking tape), fibreglass, rubber, textiles and wire.

During the late 1960s, Hesse's work was included in a variety of exhibitions and her representation was taken over by the Fischbach Gallery in New York. In 1967 Dorothy Beskind filmed the artist at work in her studio and the following year she began teaching at the School of Visual Arts in New York. Robert Morris invited Hesse to exhibit in the now legendary exhibition '9 at Castelli' (1968) that endeavoured to explore what he called 'anti-form'. Hesse died of brain tumour in New York in 1970. Her three-session interview with the art critic Cindy Nemser was published in *Artforum* that year.

Eva Hesse
Hang Up, 1966
Acrylic, cloth, wood, cord and steel, 182.9 x 213.4 x 198.1 cm (72 x 84 x 78 in.)
The Art Institute of Chicago, Chicago

This work reads more as an object projecting into space rather than as a conventional picture framed and hanging from the wall.

KEY EVENTS

1967 – Hesse takes part in the exhibition 'Working Drawings and Other Visible Things on Paper Not Necessarily Meant to Be Viewed as Art', organized by fellow artist Mel Bochner at the School of Visual Arts in New York.

1969 – Hesse's work is included in critic and curator Harald Szeemann's influential exhibition 'When Attitudes Become Form' at the Kunsthalle Bern, Switzerland.

JOAN JONAS
b.1936

I didn't see a major difference between a poem, a sculpture, a film, or a dance. A gesture has for me the same weight as a drawing: draw, erase, draw, erase-memory erased. While I was studying art history I looked carefully . . . how illusions are created within a framed space . . . When I switched from sculpture to performance, I went to a space and looked at it. I would imagine how . . . an audience . . . would perceive the ambiguities and illusions of the space. An idea for a piece would come just from looking until my vision blurred. I also began with a prop such as a mirror, a cone, a TV, a story.

Joan Jonas shows us why in her now legendary performances she conveys an array of visual and sensorial experiences through the union of different media. After studying first at Mount Holyoke College in Massachusetts and then at the School of the Museum of Fine Arts, Boston, she earned a degree from Columbia University, New York, in 1965.

The mirror is an important symbol in the work of Jonas, who regularly features mirrors in her performances. For instance, in *Mirror Piece I* (1969; opposite), one of her earliest performances, Jonas gathered together fifteen women, each holding a full-length mirror. The women were given a routine and moved within a defined area reflecting the audience in their mirrors. At random two men in suits walked through the choreographed group of women. Jonas's

Joan Jonas
Mirror Piece 1,
performance at Bard
College, 1969
Photograph by Joan Jonas

The fifteen female protagonists of *Mirror Piece 1* redirected the audience's gaze back on to themselves. This marked a break from the traditional observation pattern, which sees the artwork being observed by the audience.

chief ambition with this work was to alter space by expanding it through the mirrored surfaces, all the while asking the audience and the performers to share in the making of the piece. Jonas came back to the mirror as a prop and a signifier, in *Mirror Piece II* (1970) and *Mirror Check* (1970).

In the 1970s the artist explored the female as a subject and stereotypical assumptions attached to women; as part of this Jonas impersonated a range of female characters, ranging from the 'good witch' to the 'bad witch'. She later admitted the women's movement had a great impact on her and led her to question gender roles.

KEY EVENTS

1972 – Jonas takes part in the exhibition 'documenta 5' in Kassel, Germany.

1975 – The artist appears in *Keep Busy*, a film by the photographer Robert Frank.

2014–15 – Jonas takes part in the 'Safety Curtain' exhibition series sponsored by a private art association, the museum in progress, for the Vienna State Opera. She designs a large-scale picture used as a safety curtain in the Opera House.

2015 – Jonas represents the USA at the Venice Biennale.

JUDY CHICAGO
b.1939

Judy Chicago
The Dinner Party, 1974–9
Ceramic, porcelain and
textile, 1463 x 1280.2
x 91.4 cm (576 x
504 x 36 in.)
Brooklyn Museum,
Brooklyn

**The triangular table rests
on what Chicago calls
the 'Heritage Floor',
consisting of 2,304
hand-cast, gilded and
glazed porcelain tiles
featuring the names of
999 important women.
Each table set consists
of vulva- and vagina-like
shapes painted on the
dinner plates, which
embody the work's
paramount ambition to
raise consciousness of
the feminist cause and
its principal players. It is
now on permanent view.**

Judy Chicago is one of the leading figures of the American feminist
art movement. Born Judy Cohen, she grew up in Chicago, the
city whose name she later adopted as a pseudonym. The symbolic
transition from her paternal surname to her pseudonym was marked
by a performance, in which Chicago, kitted out as a boxer, was
prepared to fend off an androcentric society and defend her identity
– a condition of loss experienced by many women when they
married. The action was recorded by photographer Jerry McMillian
and published in the journal *Artforum* in December 1970.

While studying painting and sculpture at the University of
California, Los Angeles, Chicago experienced the hostility of her
male peers. As a result she sought refuge in Minimalist painting
before adopting a more explicitly feminist language of protest.
Together with fellow artist Miriam Schapiro, she established the
first Feminist Art Program in the United States at California State
University, Fresno, in 1970.

In 1974 Chicago began work on the seminal installation *The
Dinner Party* (opposite). Now widely regarded as a stand-out work of
feminist art, *The Dinner Party* consists of three long tables arranged
in a triangle shape with thirty-nine place settings, each honouring
an important female figure. These include the writers Mary
Wollstonecraft, Emily Dickinson and Virginia Woolf, primordial
goddesses, the warrior queen Boadicea, the Byzantine Empress
Theodora and the artist Georgia O'Keeffe, among others.

When *The Dinner Party* was first exhibited at the San Francisco
Museum of Modern Art in 1979, thousands of women queued for
hours to see the show. Nevertheless, the art world remained hostile
and the other museums set to show the work cancelled their slots
and the exhibition tour fell apart. The work ended up in storage until
it was purchased for the Brooklyn Museum in New York. Over the
years Chicago has closely linked her artistic practice to her social
activism. She lives and works in Belen, New Mexico.

KEY EVENTS

1966 – Chicago takes part in the exhibition 'Primary Structures'
at the Jewish Museum in New York. This show featuring thirty-
nine men and only three women plays a crucial role in raising
awareness of the nascent Minimalist movement.

1975 – Chicago's autobiography is published: *Through the Flower:
My Struggle as a Woman Artist*.

CAROLEE SCHNEEMANN
b.1939

Carolee Schneemann was born in Fox Chase, Pennsylvania. After attending Bard College in New York and the University of Illinois, she moved to New York in 1960. Feminist concerns and gender consciousness were central to her work from the outset. Though Schneemann was trained as a painter, she turned to film and performance as a means to raise awareness of feminist ideologies.

Schneemann used her own body to express erotic and political power. In 1964 her irreverent performance *Meat Joy* was staged in New York at the Judson Memorial Church, where performers wreaked havoc with raw meat and wet paint amid pop music. The following year in her film *Fuses* (1965), Schneemann explored sexual intimacy while questioning visual traditions. Screened at the Cannes Film Festival in 1968, *Fuses* was received with scepticism by a group of male viewers who, in protest, slashed their seats with razors. It was subsequently censored and banned from a number of venues. *Fuses* and *Meat Joy* have remained to this day prime examples of Schneemann's desire to address issues of gender and sexuality.

In 1975 Schneemann again attempted to subvert conventions with her *Interior Scroll* (opposite). Staged in East Hampton, New York, this performance saw the artist read from a scroll that she steadily pulled out from her vagina. Treating her reproductive organ as a source of knowledge, Schneemann denounced the upsetting male bias experienced by creative women.

Carolee Schneemann
Interior Scroll, 1975
Photo collage with text: beet juice, urine and coffee photographic print, 182.9 x 121.9 cm (72 x 48 in.)

Interior Scroll was performed twice. On both occasions, the reading of the scroll was accompanied by a ritual.

Since the 1970s Schneemann has produced work that addresses not only gender imbalance, but also war and memory. Alongside her performances, Schneemann has taught at many art colleges, including the California Institute of the Arts and Rutgers University, New Jersey. Schneemann lives and works in Springtown, New York.

KEY EVENTS

1962 – Schneemann is involved for the next three years with the Judson Dance Theater collective, a platform for performance, dance and theatre production in Greenwich Village, New York.

1976 – Schneemann publishes the book *Cézanne, She Was a Great Painter*.

2017 – The artist is awarded the Venice Biennale's Golden Lion for Lifetime Achievement.

CONTEMPORARY VIEWS

artists born between 1942 and 1985

-

I am a feminist, was a feminist, and will continue
to be a feminist, and . . . I consider that even in
works that are not explicitly engaged with questions
of gender politics, the work is produced from the
standpoint of a feminist

-

Martha Rosler, 2014

ANNA MARIA MAIOLINO
b.1942

Anna Maria Maiolino was born in Italy. In 1954 she moved to
Venezuela with her family and in 1960 she relocated to Brazil to
enrol at the newly created printmaking department of the Escola
Nacional de Belas Artes in Rio de Janeiro. There she developed an
interest in woodcuts and began to work on many of the recurring
themes in her art. The political situation in Latin America became
increasingly fraught and in 1964 a military coup in Brazil led to the
drastic suppression of democratic institutions by a dictatorship.
In protest, together with her future husband, Rubens Gerchman,
and fellow students Antônio Dias and Carlos Vergara, the artist
developed the style Nova Figuração (New Figuration), creating
politically charged figurative works reminiscent of Pop Art. Her work
stands out for the way Maiolino comments on the specificities of
the Brazilian political situation, while also addressing broader themes
such as cultural and geographical displacement.

Anna Maria Maiolino
ANNA, 1967
Woodcut, 47.6 x 66.4
cm (16¾ x 26⅛ in.)
Hauser & Wirth

***ANNA* is a self-portrait,
in which the artist's
name is substituted
for her image. Acting
as a palindrome,
ANNA simultaneously
addresses the joys of
birth as well as the
sorrows of death. The
two figures perched
over the sepulchre
could represent
Maiolino's parents.**

In 1968 Maiolino travelled to New York with her husband and remained there for three years. During this time she made a series of pen drawings titled *Entre Pausas* (*Between Pauses*) and two etchings, *Escape Point* and *Escape Angel*, in 1971. Back in Rio de Janeiro in the mid-1970s, Maiolino turned her attention to film and performance. In *In-Out* (*Antropofagia*) (1973) the focus is on the mouths of a man and a woman, which take up the entire screen. The camera alternates between the two mouths, which have been forced shut with tape first and then unbound, emphasizing how censorship has curtailed freedom of speech. While the political situation remained a central concern in Maiolino's work, the body and bodily matter took on a prominent role, too.

Since the 1970s her production has explored different media including drawing and the manipulation of paper, which she sewed, cut and tore to create works that she calls 'drawing objects'. Her oeuvre includes photography, film, installations and moulded sculptures. Since 1989 Maiolino has been experimenting with the material and physical properties of clay with its 'multi-form possibilities', as she pointed out when she started her exploration of the material. Maiolino lives and works in São Paulo, Brazil.

KEY EVENT

1967 – Maiolino takes part in the seminal exhibition 'Nova Objetividade Brasileira' (New Brazilian Objectivity) at the Museum of Modern Art, Rio de Janeiro.

Anna Maria Maiolino
Entrevidas (*Between Lives*), from the series *Fotopoemação* (*Photopoemaction*), 1981
Gelatin silver prints, each 144 x 92 cm (56¾ x 36¼ in.)
Hauser & Wirth

***Entrevidas* ponders the experiences of tension and fear suffered during dictatorships. Built around a series of analogies, which see the eggs as the repressed subjects and the feet as the oppressive dictators, *Entrevidas* emphasizes the vulnerability of the eggs as the feet walk through them.**

GRACIELA ITURBIDE
b.1943

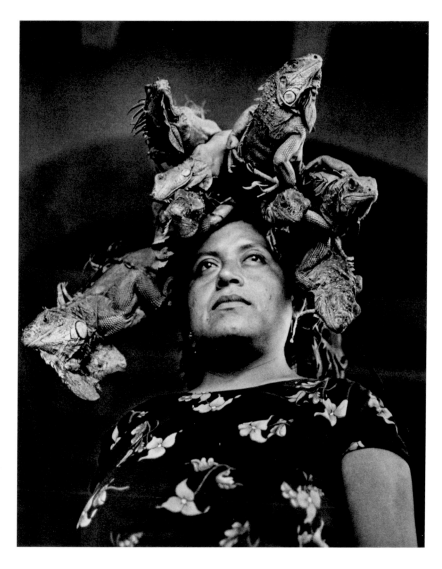

Graciela Iturbide
Nuestra Señora de las Iguanas, Juchitán, México, 1979
Gelatin silver print, 53.3 × 43.2 cm (21 × 17 in.)
ROSEGALLERY, Santa Monica

This photograph, which shows a woman with a crown made out of live iguanas, has acquired a legendary status. When Iturbide was invited to Japan to receive an award, this image was reproduced in place of her portrait on the invitation. When she arrived, the museum director was pleasantly surprised that Iturbide had come without an iguana.

Graciela Iturbide is one of Mexico's foremost living photographers. Born in Mexico City, Iturbide first came to photography as a means of overcoming the loss of her six-year-old daughter in 1969. That year she enrolled in the Centro Universitario de Estudios Cinematográficos in Mexico City, where she studied film directing and photography. Around the same time Iturbide worked as an assistant to Manuel Álvarez Bravo, one of Mexico's best known photographers; this experience was instrumental in making her see things differently. She credits her ability to capture on camera the spontaneity of an instant to her brief apprenticeship with the great French photographer Henri Cartier-Bresson.

Iturbide mostly works with black-and-white photography, as this medium provided the sense of detachment she sought with her portraits, which combine austerity with beauty. In terms of subject matter, the photographer's work has primarily dealt with the documentation of the indigenous people of Mexico. In 1978 Iturbide was commissioned by the Instituto Nacional Indigenista to record the waning indigenous world by taking photographs of the Seri people in the Sonoran Desert in the north of Mexico.

In 1979 the Oaxaca-based painter Francisco Toledo invited Iturbide to the town of Juchitán where he was born and, through Toledo, the photographer became acquainted with the indigenous Zapotec people. Renowned for their matriarchal structure, the Zapotec entrust women with the organization of public life, the household as well as finances and politics, while men work in the fields. For a period of ten years Iturbide lived in Juchitán, where she produced some of her most iconic photographs, including *Nuestra Señora de las Iguana* (*Our Lady of the Iguanas*; 1979; opposite). An explanation for its success rests in its ability to capture the power of the indigenous world with its myths and legends. Also, as Iturbide has explained, a mythical image of this kind becomes a site for projection, allowing viewers to variously interpret it. Tellingly, Iturbide describes the genesis of this image:

> If anyone looked at the contact sheet I had for *The Iguana Women* (and it might be interesting to publish it some day) they would see how the woman is laughing, that the iguanas were dropping their heads down. It was a miracle I got to snap a frame in which they were resting placidly for a moment. I never imagined it would become a photo that might really interest the Zapotec people themselves

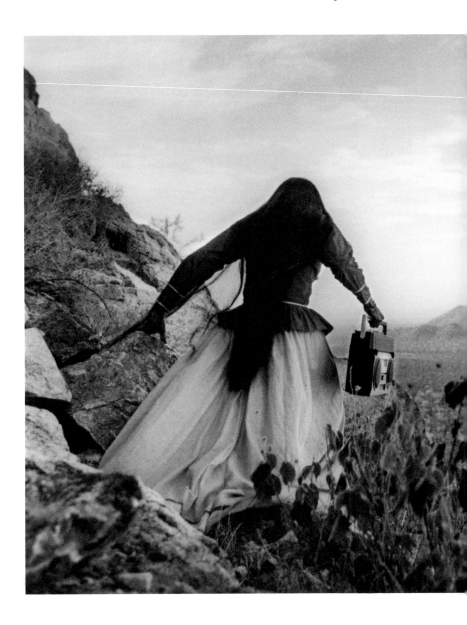

KEY EVENTS

2005 – Iturbide is allowed to photograph Frida Kahlo's bathroom,
 which had been left untouched since the artist's death. She
 used colour film to convey her emotion.

Graciela Iturbide
Mujer Ángel, desierto de Sonora, México, 1979
Silver gelatin print, 40.3 x 56.8 cm (15⅞ x 22⅜ in.)
ROSEGALLERY, Santa Monica

This photograph, translated as *Angel Woman, Sonora Desert,* captures the tension between modernity and tradition, exemplified by the indigenous woman wearing a traditional costume and marching through the desert with a tape recorder in hand. The picture appeared in the book *Los que viven en la arena (Those Who Live in the Sand),* published in 1981.

2013 – The Museo Amparo in Puebla host a show of Iturbide's *Travel Notebooks,* collected during her trips to India, Italy and the United States.

MARTHA ROSLER
b.1943

Martha Rosler has worked in a range of media, including installation, photography, sculpture, video and text. Her art and activism are often inseparable and she has engaged with feminist discourses, as well as other social concerns, through critical writing and theoretical investigations. In keeping with her awareness-raising efforts, the artist's output is not merely confined to the art world but makes use of multiple outlets, including newspapers, mail-outs and garage sales. Paying great attention to sensitive gender, social and political, Rosler has explored issues such as war, the media and the built environment. For instance, in *If You Lived Here . . .* (1989), she invited artists, activists, architects, homeless people and others to examine the emerging crisis of homelessness and its relation to questions of urban housing and social support.

Rosler received a Bachelor's degree in Literature from Brooklyn College in 1965 and an Master of Fine Arts from the University of California, San Diego in 1974. In the late 1960s and early 1970s, she engaged with photomontage in her now iconic *Body Beautiful, or Beauty Knows No Pain* series. Rosler, like Hannah Höch before her, turned to photomontage as a means of drawing attention to contemporary political and feminist issues.

The ongoing concerns of feminism are central to Rosler's work. Her video *Semiotics of the Kitchen* (1975; opposite) features the artist donning an apron and presenting her audience with a range of kitchen hand tools, including a carving knife, a metal hamburger press, a tenderizer and so on. With the camera subtly zooming in on the changing bodily gestures within one single shot, *Semiotics of the Kitchen* spoofs popular cooking programmes like Julia Child's *The French Chef*. Rosler, while keeping a straight face, embarks here on an alphabetical revision of kitchen utensils to convey her anger and frustration at the domestic impositions typically enforced on women. Rosler lives and works in Brooklyn, New York, the place of her birth.

Martha Rosler
Semiotics of the Kitchen, 1975
Video (black and white, sound), duration: 6:09 mins
Electronic Arts Intermix (EAI), New York

Testament to *Semiotics of the Kitchen*'s enduring appeal are the many extant cover versions of the video, including one featuring Barbie. No food was included in this broadcast, which visualizes the semiotics of the kitchen through the instruments of torture associated with everyday chores. The lasting success of this influential video can be credited to Rosler's sense of irony coupled with her outspoken critique of rigid gender roles.

KEY EVENTS

2012 – Rosler organizes the 'Meta-Monumental Garage Sale' at the Museum of Modern Art (MoMA) in New York. Modelled on a typical American garage sale, visitors were invited to browse and purchase second-hand items.

2013 – *Culture Class*, Rosler's collection of essays looking at the impact of gentrification and the role of artists in cities is published by e-flux and Sternberg Press, New York.

MARINA ABRAMOVIĆ
b.1946

Marina Abramović is most notorious for her performances. Often challenging and requiring a high degree of endurance from the artist, these performances bring to light human vulnerability, among other themes. From 1965 to 1970, Abramović studied at the Academy of Fine Arts in Belgrade, former Yuogslavia, and from 1970 to 1972 she pursued her post-graduate studies at the Academy of Fine Arts in Zagreb, Croatia. While she started out as a painter, she soon abandoned this medium in favour of performance and body art.

The artist's own body played a central role in her early works. For example, in *Rhythm 10* (1973) she turned on a tape recorder and then rapidly stabbed a knife between her splayed fingers. Through this action the artist consciously injured herself while also demanding the audience's participation and specifically their emotional response. The participatory ambition of Abramović's performances was made explicit by *Rhythm 0*, performed in Naples in 1974. Here, she surrendered herself to the gallery visitors, who were offered seventy-two objects with which they could stimulate, physically injure or humiliate the artist. To this day audience participation is integral to Abramović's practice.

In 1975 Abramović met the German artist Ulay (F. Uwe Laysiepen) and for the following thirteen years was artistically and romantically involved with him. The pair created a number of performances together, including their farewell, which they turned into a performance. Staged along the Great Wall of China, *The Lovers: Walk on the Great Wall* saw Abramović walking from the Yellow Sea, while Ulay started in the opposite direction from the Gobi Desert. The couple met in the centre and then parted ways for good. This theatrical break-up suggests the degree to which Abramović's persona is at the centre of her work.

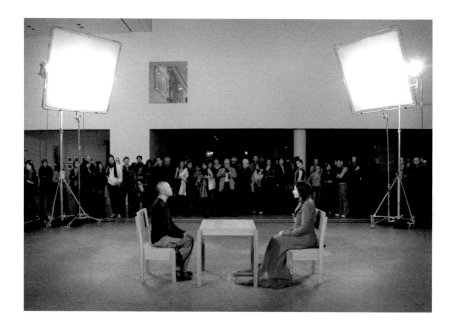

Marina Abramović
The Artist is Present, 2010
Three-month
performance,
photographed by
Marco Anelli
Museum of Modern Art
(MoMA), New York

**Abramović sat silently
at a table for eight hours
a day for nearly three
months. One by one,
members of the public
were invited to sit in the
empty chair opposite
Abramović and lock
eyes with her. Over a
thousand participants,
including many who
queued for hours, took
part in this apparently
simple yet emotionally
challenging experience.
The intensity of this
performance moved
many of them to tears.**

KEY EVENTS

1997 – Abramović is awarded the Golden Lion for Best Artist at
the 1997 Venice Biennale.

2005 – Abramović stages *Seven Easy Pieces* at the Guggenheim
Museum in New York. On seven consecutive nights she reenacts
her own *Lips of Thomas* (fisrt performed in 1975) as well as
performances by Joseph Beuys and Vito Acconci, among others,
dating from the 1960s and 1970s.

2008 – Abramović is awarded the Austrian Commander Cross for
her contribution to art history.

2012 – The Marina Abramovic Institute for the Preservation of
Performance Art (MAI) in Hudson, NY, is set up to create new
possibilities for collaboration among thinkers within all fields
across the sciences and the arts.

ANA MENDIETA
1948–85

Ana Mendieta was born in Havana, Cuba, in 1948. In 1959
Fidel Castro became Prime Minister of Cuba, and in 1961 he
implemented a Marxist-Leninist government that led to a diplomatic
break with the United States. At first a supporter of Castro's
revolution, Mendieta's father later joined the clandestine anti-
Castro movement. Aware of the risks, he enrolled his children in the
Operation Peter Pan, a programme that helped expatriate children
who came from Cuba. In 1961 Mendieta and her older sister,
Raquelín, were sent to the USA, where they spent the following
years moving between religious institutions and foster families.

From 1967 to 1972 Mendieta attended the University of Iowa,
where she created provocative performances such as *Chicken Movie,
Chicken Piece* (1972) and produced her earliest photographic series
featuring her face and body. In 1971 she travelled to Mexico for
the first time, and it is here in 1973 that she first conceived of her
Siluetas (silhouettes) series – photographs featuring Mendieta's
body or her silhouette imprinted in the landscape. Through such a
strategy, she explored ideas around identity, gender and spirituality.
After 1975 the artist's work underwent a fundamental transition, in
that, from this point onwards, Mendieta almost never included her
own body directly into her work again.

An important feature of Mendieta's work is the identification of
the female figure with nature. As she explained:

> the way I really thought about it was of having nature take over
> the body, in the same way that it had taken over the symbols of
> past civilizations . . . That's the way I feel when I face nature, that
> it's just the most overwhelming thing there is.

Mendieta's experience of the power of nature was expressed in
such works as *Tree of Life* (1976; opposite) where the artist and the
trunk of a tree become one. In 1978 she joined the A.I.R. Gallery,
the first gallery in the United States exclusively dedicated to women
artists. Mendieta died tragically in 1985, falling from the window
of the New York apartment she shared with the Minimalist artist
Carl Andre.

Ana Mendieta
Tree of Life, 1976
Colour photograph, 50.8
x 33.7 cm (20 x 13¼ in.)
Courtesy Galerie Lelong
& Co., New York

**The artist's mud-clad
silhouette is pressed
against the tree, a symbol
of life and regeneration.**

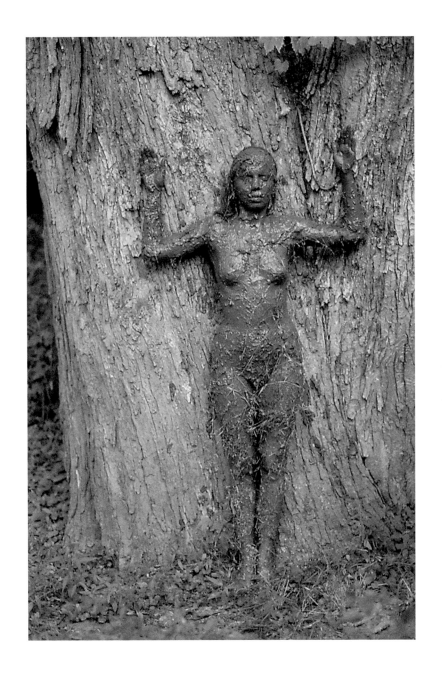

KEY EVENT

1983 – Mendieta receives the Rome Prize from the American
Academy in Rome. She spends the following year there,
creating drawings and sculptures.

CINDY SHERMAN
b.1954

Cindy Sherman has often used her own body to question social stereotypes. By adopting multiple guises and varying identities, Sherman has continually transformed herself and her art. While she majored in painting at Buffalo State College in 1972, she turned to photography in 1974, which has been her medium of choice ever since. From a young age Sherman had been fascinated by costumes and make-up, and by the time she graduated this early passion had become central to her work. Sherman had begun to create fictional characters by manipulating her appearance. In her early series of photographs *Bus Riders* (1976), Sherman impersonates a number of different urban characters set against a white wall.

In 1977 she moved to New York where she worked as a part-time receptionist at Artists Space. That year, she also began work on the *Untitled Film Stills* (1977–80) series. Comprised of sixty-nine black-and-white photographs, this body of work represents a milestone of art history. In it, Sherman impersonates a series of female stereotypes evoking the quality and feel of film noir or B-movies. In *Untitled Film Still #21* (1978; opposite), where Sherman is captured in an outdoor setting, the shot is intended to replicate cheap film productions. *Film Still #21* blurs the line between portraiture and stereotypical female roles inspired by mid-century Hollywood films. Here Sherman discusses her work:

> It was the way I was shooting, the mimicry of the style of black and white grade-Z motion pictures that produced the self-consciousness of these characters, not my knowledge of feminist theory . . . I wasn't working with a raised 'awareness,' but I definitely felt that the characters were questioning something – perhaps being forced into a certain role. At the same time, those roles are in a film: the women aren't being lifelike, they're acting. There are so many levels of artifice.

Cindy Sherman
Untitled Film Still #21,
1978
Gelatin silver print, 20.3 x 25.4 cm (8 x 10 in.)
Museum of Modern Art (MoMA), New York

Untitled Film Still #21 is one of sixty-nine film stills from the eponymous series. Sherman invites us here to think about femininity and its representation in popular culture, specifically film. The female heroine is filled with expectation: she is wearing a perfectly trimmed suit and her make-up is impeccable. A portrayal of youth and success, *Film Still #21* alludes to the way generic types, like the one pictured here, shaped the visual landscape of post-war America.

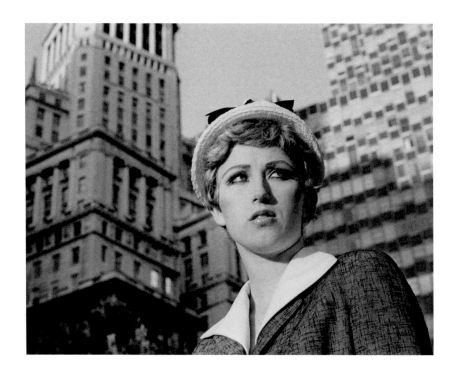

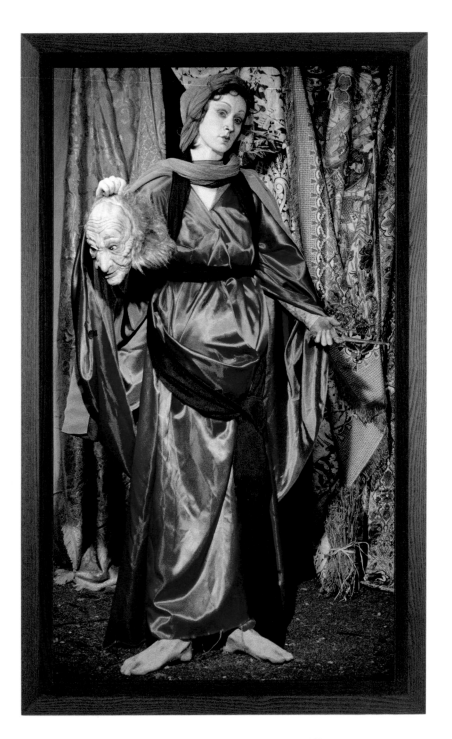

Cindy Sherman
Untitled #228, 1990
Chromogenic colour
print, 221.6 x 135.6 cm
(87¼ x 53⅜ in.)
Museum of Modern Art
(MoMA), New York

Untitled #228 belongs
to the *History Portraits*
(1988–90) series.
In these works, Sherman
represents herself as
figures from Old Master
paintings, ranging from
the Baroque to the
Neoclassical period.
In *Untitled #228*, she
plays the role of the
biblical heroine Judith,
who is holds the mask-
like head of Holofernes
in one hand.

From Sherman's words it can be deduced that her work is concerned with artifice and the blurring between reality and fiction rather than a clear feminist stance. Nevertheless, her practice has played a key role in shaping a visual discourse around femininity. Since *Untitled Film Stills* most of Sherman's work is organized in thematic series, these include *Centerfolds* (1982), *Fairy Tales* (1985), *Sex Pictures* (1992), *Hollywood/Hampton Types* (2000–2), *Clowns* (2003–4) and *Society Ladies* (2008).

KEY EVENTS

Mid-1970s – Sherman is part of Hallwalls, an alternative living and working space established by the artists Robert Longo and Charles Clough in Buffalo, New York.

1997 – The artist shoots *Office Killer*, her first feature film.

2012 – A retrospective of Sherman's work at the Museum of Modern Art (MoMA), New York, includes over 170 works from the 1970s to the present.

2019 – The National Portrait Gallery, London, holds an exhibition of 180 of Sherman's self-portraits.

FRANCESCA WOODMAN
1958–81

'I have a lot of ideas cooking [– I] simply need to get started working before they stick to the bottom of the pan,' stated the photographer Francesca Woodman. She was born into a family of artists and was raised between the United States and Italy. In 1972, using a self-timer, she took her first self-portrait and her earliest photograph in existence, entitled *Self-Portrait at Thirteen*. Between 1975 and 1978 Woodman studied at Rhode Island School of Design (RISD) in Providence where she experimented extensively with photography. The image opposite from the series *Polka Dots, Providence, Rhode Island* (1976) was made during her time at RISD. Like most of Woodman's photographs made around the same time, the overriding mood is melancholic. We see the artist crouched in what appears to be an abandoned home, as she stares at the camera anxiously and with a sense of fearful expectation. Her cheerful polka dot dress is set in stark contrast with the dilapidated surroundings, lending to the image a tension between the artist's figure and the architectural setting.

Woodman's own body was central to her artistic practice. Through her self-involvement she questioned stereotypical images of femininity and in doing so she critiqued the treatment of women as objects rather than subjects. Woodman's compositions are, however, imbued with a sense of ephemerality and precariousness that treads the line between the concrete representation of reality and an imagined *mise-en-scène*. As an enhancement to her scenes, but also as a form of disruption, Woodman introduces a range of props, which challenge and detract from the bodily emphasis of the photographs.

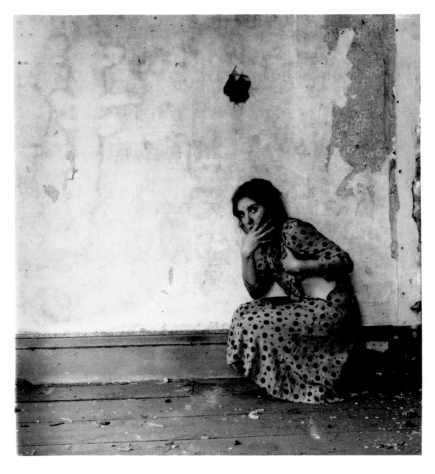

Francesca Woodman
From *Polka Dots,*
Providence, Rhode Island,
1976
Gelatin silver estate print,
13 x 13 cm (5⅛ x 5⅛ in.)
Courtesy Charles
Woodman and Victoria
Miro Gallery, London

**Woodman draws
attention to the
ambiguous nature of
self-portraiture as a
genre. This photograph
reveals as much as
it conceals about the
true nature of the
depicted figure.**

Between 1977 and 1978 the artist spent a year in Rome, where she had a solo exhibition at the Surrealist bookshop Libreria Maldoror. *Untitled* (1977–8; opposite) was made during Woodman's Roman sojourn. Only the back of the artist is visible in this overexposed photograph, where the body in its fragmented state takes on an abstract connotation. Through this vexing fragmentation, Woodman explicitly counters the wholeness of classical nudes. Her body rejects the male gaze, which had long dominated depictions of femininity, and disrupts it by engaging it in fractional terms. By 1979 when Woodman returned to New York, she was experimenting with colour photography. On 19 January 1981 Woodman committed suicide, only a few weeks after her book of photographs *Some Disordered Interior Geometries* was published.

KEY EVENTS

1968 – The Woodman family spends the summer in Fiesole, Tuscany, Italy and buy a house in Antella outside Florence.

1976 – The artist has her first solo exhibition at the Addison Gallery of American Art, Andover.

Francesca Woodman
Untitled, Rome, Italy,
1977–8
Gelatin silver estate print,
19.7 x 19.5 cm (7¾ x
7¹¹⁄₁₆ in.)
Courtesy Charles
Woodman and Victoria
Miro Gallery, London

**The artist's work has
frequently been linked
to Surrealism due to the
uncanny quality that
infuses many of her
photographs.**

OLGA CHERNYSHEVA
b.1962

Olga Chernysheva
Untitled [Good Morning],
2014
Charcoal on paper,
collage, 84 x 60 cm
(33⅛ x 23⅝ in.)
Private collection, London

**In her drawings
Chernysheva surveys the
sociological landscape by
focusing on individual
types. The focus of this
idiosyncratic work is on
a rather quizzical figure
clad in a bear costume.
A possible stand-in for
an advertisement of some
kind, the bear evades a
definitive interpretation,
and this is precisely the
point. The juxtaposition
between the image
and the strip of text
complicates things
further.**

Russian realism is the first layer of our mental make-up . . .
We were conscious of Russian realism before we began to see
art as something separate from life. It was as if these paintings
had generated themselves; the name of the author was not that
important. Their universal role wasn't limited to art but covered
all of life's humanist foundations.

Here the Moscow-based artist Olga Chernysheva considers how
Socialist Realist painting dominated Soviet Russia when the applied arts
were more important than fine art, which was considered too elitist.
Books, illustrations and animations could be circulated more widely and
have a stronger impact (also in terms of propaganda).

Empty and full subjects

Olga Chernysheva
Untitled [Empty . . .], 2016
Charcoal on paper,
collage, 84 x 52 cm
(33⅛ x 20½ in.)
Private collection,
Los Angeles

Through her poetic lens, Chernysheva captures ordinary scenes. This one relays the experience of ascending and descending subway escalators. As a social site the metro station brings together different social types, each proceeding in their own way. By focusing on such a mundane scene, the artist brings to our attention the particular and the details that might overwise have been overlooked.

The beginning of Chernysheva's career in the late 1980s and early 1990s coincided with the collapse of the Soviet Union and its aftermath. In 1986 she graduated from the animation department of Moscow's Gerasimov Institute of Cinematography (VGIK), where she studied art, as well as film history and production. Today Chernysheva's work includes drawing, painting, photography and video.

The artist has long been considering the heritage of Soviet art and its lingering influence. In particular, Chernysheva has been fascinated by the interjection of realism and the depiction of social types. From street vendors to the uniformed guards presiding over Moscow's underground, Chernysheva is a sensitive chronicler of the everyday, capturing the minutiae that often go unnoticed.

KEY EVENTS

1995–6 – Chernysheva completes a residency at the
 Rijksakademie van Beeldende Kunsten, Amsterdam.
2015 – The artist is invited by the Drawing Center in New York
 to spend a month in the city, where she chronicles the life of
 the metropolis and its citizens. The resulting collection of
 drawings is exhibited in 'Vague Accent', a solo presentation of
 Chernysheva's work at the Drawing Center in 2016.

RACHEL WHITEREAD
b.1963

Rachel Whiteread is one of Britain's most prominent artists. Although best known as a sculptor, Whiteread also works in drawing, photography and video. From 1985 to 1987 she studied sculpture at the Slade School of Fine Art and was involved with the Young British Artists (YBAs), who in 1997 were featured in the Royal Academy's exhibition 'Sensation', which brought to the fore a whole host of younger artists including Whiteread.

Whiteread's work deals with space, the relationship between inner and outer forms, and the life of everyday objects, like bathtubs and closets. The link between inner and outer forms is developed through casts, which are formed when liquid matter is poured into a solid form and then left to solidify. Thus, in her sculptures, which range from the intimate to the monumental, she reveals what often remains concealed to the eye. In *House* (1993), for instance, she created a concrete cast of a house on Grove Road in East London. The house was stripped of its exterior structure leaving just the interior as a reminder of its former self. The three-storey building stood as a monument to how a private interior could be made public for all to see. Other than concrete, Whiteread's vocabulary of materials has included plaster, resin, rubber and metal, with each redeployed to capture most accurately the nuances of the interiors that the artist was seeking to replicate. In *Ghost* (1990; opposite) she faithfully recorded through plaster casting the interior of a room inside a nineteenth-century English house. London and its urban development are a central concern of Whiteread's work. *House*, for example, draws attention to how older London homes are besieged by ruthless redevelopment campaigns.

More recently Whiteread was commissioned to design the Judenplatz Holocaust Memorial in Vienna, in which she created an imposing structure resembling the shelves of a library with the books' pages turned outwards. Through these endless unreadable books, Whiteread memorializes the tragic destruction of human lives during the Holocaust. The books act as lyrical stand-ins conveying feelings of loss and memory. Despite its stark appearance, Whiteread's work calls for an intimate encounter and brings to the fore memories and histories that transcend the sculptural installation. The artist lives and works in London.

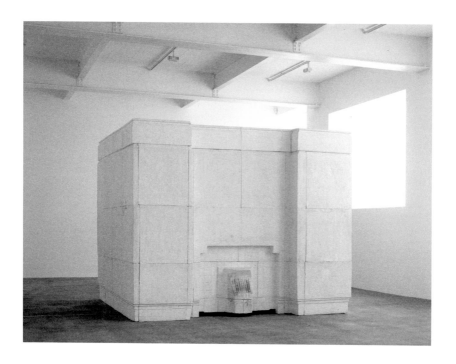

Rachel Whiteread
Ghost, 1990
Plaster on steel frame,
269 x 355.5 x 317.5 cm
(105⅞ x 139¹⁵/₁₆ x 125 in.)
National Gallery of Art,
Washington, DC

The title '*Ghost*' conveys
the idea of an apparition,
of a presence that usually
remains out of sight.

OTHER KEY WORKS

Untitled (Paperbacks), 1997, Museum of Modern Art (MoMA), New York, NY, USA

Untitled (Stairs), 2001, Tate, London, UK

Untitled (Rooms), 2001, Tate, London, UK

KEY EVENTS

1993 – Whiteread is the first woman to win the prestigious Turner Prize. The very same day the local council agree to demolish the work, following the harsh criticism that *House* had triggered among local inhabitants. In January 1994 the work is destroyed and only black-and-white pictures and video documentation survive.

2003 – Whiteread is invited by the BBC Public Art Programme to create a work based on Room 101 of BBC Broadcasting House, shortly before it was destroyed. This specific room is said to have inspired the torture chamber described in George Orwell's dystopian novel, *1984*, published 1949.

TRACEY EMIN
b.1963

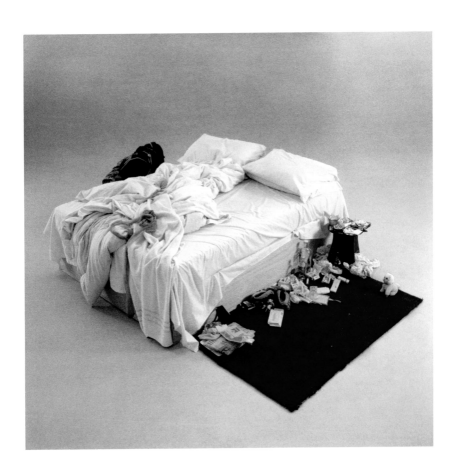

The British artist Tracey Emin is best known for her autobiographical work. Through the use of different media – painting, drawing, moving image, installation, photography, needlework and sculpture – she explores the successes and failures of her personal life. Works, such as *My Bed* (1998; opposite), are both sexually provocative and ridden with a sense of loss and fragility. *My Bed* consists of the artist's own unmade dirty bed, following several weeks of emotional turmoil and subsequently staying in bed for four days.

Everyone *I Have Ever Slept With 1963–1995* (1995), a tent covered with appliquéd names of all the people with whom the artist had ever shared a bed, is similarly based on the artist's life experience. As demonstrated by this piece, Emin often appropriates traditional handicraft techniques, such as appliqué and embroidery, and repurposes them with a subversive intent. At once intimate and provocative, her artworks tread the line between private confessional and public exposure. Emin has been closely linked with the Young British Artists and her work was featured in 'Sensation', the groundbreaking yet controversial exhibition held at London's Royal Academy of Arts in 1997. She is a graduate of Maidstone College of Art and the Royal College of Art, London.

Tracey Emin
My Bed, 1998
Mattress, linens, pillows, objects, dimensions variable
On loan to Tate Modern, London

Strewn around the bed is a clutter of personal effects: empty vodka bottles, slippers and underwear, crushed cigarette packs, condoms and contraceptives, a cuddly toy and several Polaroid self-portraits. Emin presented her bed exactly how it looked during a difficult period in her life.

OTHER KEY WORKS

Why I Never Became a Dancer, 1995, Tate, London, UK
For You, 2002, Liverpool Cathedral, Liverpool, UK
The Distance of Your Heart, 2018, Bridge and Grosvenor streets, Sydney, Australia

KEY EVENTS

2004 – *The Last Thing I Said To You Is Don't Leave Me Here* (*The Hut*; 1999), destroyed in a warehouse fire, East London.

2007 – Emin was the second female artist ever to represent Britain at the Venice Biennale.

2013 – Queen Elizabeth II appointed her Commander of the Most Excellent Order of the British Empire for her work in the visual arts.

2012 – Emin was one of twelve British artists selected to design and produce a limited edition poster for the London Olympic and Paralympic Games.

LYNETTE YIADOM-BOAKYE
b.1977

Lynette Yiadom-Boakye
Mercy Over Matter, 2017
Oil on canvas, 200.5 x
120 cm (78.9 x 47.2 in.)
Courtesy the artist,
Corvi-Mora, London, and
Jack Shainman Gallery,
New York

**The muted colours, the
generic clothing and the
unclear backgrounds
enhance the ambiguity of
Yiadom-Boakye's fiction.**

Lynette Yiadom-Boakye is an artist of Ghanaian descent based in
London. She attended Central Saint Martins, London, Falmouth
University and the Royal Academy Schools, London. Portraiture is
central to Yiadom-Boakye's work although, as she points out, all of
the figures in her portraits are fictional:

> I've been working on a series of portraits. None of them is of
> existing people, but they are familiar. My roll call is growing
> and it contains some of my favourite characters. They
> include Grammy winners (gracious in acceptance of awards),
> revolutionaries, fanatics, anthropologists and missionaries
> (good for showing us how to live), savages (good for showing
> us how far we have come and how not to live), radicals and the
> generally angry, amongst others.

These words capture the essence of Yiadom-Boakye's work, which treads the line between fiction and reality. Conjured from memory or from the many visual stimuli encountered by the artist in her daily life, her portraits are a product of her imagination. The tradition of portraiture is reasserted in these ambiguous visions. Yiadom-Boakye's pictorial style is reminiscent of nineteenth-century painters like Édouard Manet and James Abbott McNeill Whistler. Like them Yiadom-Boakye presents the viewer with numerous characters, ranging from dancers to bathers. The strength of this modern portraitist rests in her overt deception of reality through naturalistic means. The artist lives and works in London.

KEY EVENTS

2013 – The artist's work is included in 'The Encyclopedic Palace', the 55th Venice Biennale.

2013 – Yiadom-Boakye is nominated for the Turner Prize for her 2012 exhibition at the Chisenhale Gallery in London.

Lynette Yiadom-Boakye
*To Douse the Devil
for a Ducat*, 2015
Oil on canvas,
200 x 180 x 3.7 cm
(78.7 x 70.8 x 1.5 in.)
Courtesy the artist,
Corvi-Mora, London and
Jack Shainman Gallery,
New York

The two figures are intertwined while each one is also graciously balanced on one foot. Their poses call to mind the choreographed figures of classical ballerinas, while their expressions suggest a longstanding friendship. Like in all of Yiadom-Boakye's works, a fiction is at play here and this is just one of many possible interpretations.

AMALIA PICA
b.1978

Communication is at the heart of Amalia Pica's practice. Born in Neuquén, Patagonia, and raised during a period of state dictatorship in Argentina, Pica has questioned and explored the role of language in her work. The reception and the delivery of messages, as well as exchanges between people, have been the focus of Pica's drawings, installations, sculptures, photographs, performances and videos. For example, in the performance piece *Strangers*, Pica investigates the communication between strangers, as suggested by the title. Two strangers are asked to each hold one end of a colourful bunting. The distance between them, however, prevents the two from ever establishing an intimate conversation.

In $A \cap B \cap C$ (read as 'A intersection B intersection C'; 2013; opposite), Pica yet again examines the interactions between people. Here she provides a group of performers with a set of acrylic coloured shapes and asks them to mingle by holding up the shapes in unexpected combinations. Endlessly variable, $A \cap B \cap C$ draws attention to another phenomenon that Pica had explored in her *Venn Diagram (under the spotlight)* (2011): the coercion of education by the suppressive Argentinian regime. Venn diagrams were banned and thus omitted from Argentinian textbooks in the 1970s because the concept of intersection was deemed to be potentially subversive. By reasserting the need for exchange and overlap, Pica refers to contemporary issues around communication as well as historical ones. The artist lives and works between London and Mexico City.

Amalia Pica
$A \cap B \cap C$, 2013
Performance and Perspex forms
Courtesy of Herald St, London

With every performance, the composition takes a different form and at the end of each performance, the shapes are stored on a set of raised shelves set against a wall – again different every time.

KEY EVENTS

2011 – Pica takes part in 'ILLUMInations' the 54th Venice Biennale.

2011 – The artist is the recipient of a Paul Hamlyn Foundation Award for Artists.

GUERRILLA GIRLS
founded 1985

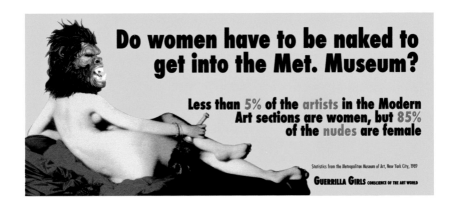

In 1989 the feminist activist collective the Guerrilla Girls asked: 'Do women have to be naked to get into the Met. Museum?' This provocative question, later turned into a screenprint, was an awareness-raising effort aimed at museum goers, collectors and art world people. The Metropolitan Museum of Art, New York, one of the world's finest and most famous institutions, was exhibiting work almost entirely produced by male artists. As the Guerrilla Girls reported: 'less than 5% of the artists in the Modern Art Sections are women, but 85% of the nudes are females.' The Guerrilla Girls were concerned here with the troubling issue that women and their bodies had long been the protagonists of modern art, and yet their work as artists had remained unrecognized. As this book has demonstrated, women for centuries have struggled to emerge, to exhibit and to be taken seriously by their male peers – the Guerrilla Girls dressed up as gorillas sought to remedy this through their humorous and provocative interventions.

Guerrilla Girls
Do women have to be naked to get into the Met. Museum?, 1989
Off-set print on paper, 28 x 71 cm (11 x 28 in.)
Courtesy the Guerrilla Girls

The Guerrilla Girls' output comprises screenprints – like the one illustrated here – as well as posters, billboards and a rectified art historical survey written from a feminist perspective.

The trigger for the birth of the Guerrilla Girls was an exhibition entitled 'An International Survey of Painting and Sculpture' held at the Museum of Modern Art in New York in 1985. Out of 169 artists participating in this exhibition only thirteen were women. As a result the Guerrilla Girls were compelled to make their first public appearance by protesting in front of the museum to highlight this unfair discrepancy.

Since 1985 this supposedly heterogeneous group of women, whose identity is concealed by gorilla masks inspired by King Kong, has been a constant presence in the American and international artistic landscape. The group's aim is to rectify the gender imbalance of the art world while also addressing pressing social and political issues, such as war and abortion. As a means of further enhancing their feminist mission, the Guerrilla Girls have each adopted the name of a legendary woman artist or writer (many of whom are included in this book), such as Paula Modersohn-Becker, Eva Hesse and Frida Kahlo.

KEY EVENTS

1995 – The Guerrilla Girls publish *Confessions of the Guerrilla Girls*, a history of the movement.

1998 – The awareness-raising book *A Guerrilla Girl's Bedside Companion to the History of Western Art* comes out.

2005 – The Guerrilla Girls take part in the Venice Biennale with their evocative billboards: 'Welcome to the Feminist Biennale' addressing the issues of gender and racial imbalance. In Venice they also explore the holdings of Venetian museums highlighting the fact that works by women artists are mostly kept in storage rather than being exhibited in galleries.

1558
Elizabeth I becomes Queen of England – a charismatic stateswoman.

1596
Hardwick Hall is completed, designed and built by Elizabeth Talbot (Bess of Hardwick); it was one of the grandest country houses in Elizabethan England.

1678
Venetian Elena Cornaro Piscopia is the first woman to receive a PhD degree.

1762
Catherine II, Empress of Russia, becomes the country's longest-ruling female leader and progressive reformer (r.1762–96).

1776
Abigail Adams, American revolutionary, abolitionist and feminist, asks her husband John Adams, second President of the United States, to 'remember the ladies and be more generous and favourable to them than your ancestors'.

1792
English writer, philosopher and advocate of women's rights Mary Wollstonecraft publishes *A Vindication of the Rights of Woman*, in which she calls for educational and social equality for women.

1828
German scientist Caroline Herschel receives the Royal Astronomical Society's gold medal. She is the first woman to discover a comet.

1867
The London Society for Women's Suffrage is formed to campaign for votes for women.

1876
Pioneering Finnish gymnast Elin Kallio founds the first association in Finland for female gymnasts.

1888
Marie Popelin is the first Belgian woman to receive a doctorate in law from the Université Libre de Bruxelles. She was denied admittance to the bar association because of her sex and went on to co-found the Belgian League for the Rights of Women.

1889
Sofya Kovalevskaya is the first female mathematics professor at the University of Stockholm. In 1888 she had been the first woman to be nominated corresponding member of the Russian Academy of Sciences.

1900
Women compete in the Olympics for the first time (tennis, sailing, croquet, equestrian sports and golf).

1901
Marie Heim-Vögtlin, a physician, co-founds the first Swiss gynaecological hospital run by all female staff.

1911
First ever International Women's Day is celebrated in Austria, Denmark, Germany and Switzerland.

Marie Curie, discoverer of radium, is the first woman to win a Nobel Prize.

1915
Women from the United States and Europe meet in The Hague in the Netherlands for the first International Congress of Women.

1916
Family planning pioneer Margaret Sanger opens the first birth control clinic in the United States.

1917
Women in Russia strike for 'bread and peace', initiating the Russian Revolution.

1920

1942

1970

1920
The Treaty of Versailles states that women must receive pay equal to their male counterparts.

1923
Margaret Sanger opens the first legal, physician-run birth control clinic in the United States.

1926
Gertrude Ederle is the first woman to swim the English Channel.

1928
Women compete in athletics and gymnastics for the first time in the Olympics.

1931
Gertrude Vanderbilt Whitney is the first woman to found a major museum: The Whitney Museum of American Art in New York, NY.

1946
The United Nations Commission on the Status of Women is formed.

1948
The American musician considered a founder of women's musicology studies, Sophie Drinker, publishes *Music and Women: The Story of Women in their Relation to Music*.

1949
Simone de Beauvoir's *The Second Sex* is published.

1952
Israel makes gender discrimination illegal with the Women's Equal Rights Act.

1963
Betty Friedan publishes *The Feminine Mystique*, a key text for the women's movement.

1963
The Russian cosmonaut Valentina Tereshkova becomes the first woman in space.

1966
Indira Gandhi becomes India's first female Prime Minister.

1971
Helga Pederson is the first female judge at the European Court of Human Rights.

1975
The Pregnancy and Discrimination Act is passed to prohibit discrimination on the basis of pregnancy, childbirth or related medical conditions.

1979
Mother Teresa is awarded the Nobel Peace Prize for her work in India.

1988
Benazir Bhutto, Prime Minister of Pakistan, is the first woman in modern history to lead a Muslim country.

1993
Toni Morrison becomes the first African-American woman to win the Nobel Prize for literature.

2001
Women's voting rights are withdrawn in Kuwait following their introduction in 1999.

2009
Michelle Obama becomes the first African-American First Lady of the United States

2017
The #MeToo movement against sexual harassment and assault spreads virally on social media.

2018
The National Gallery, London, acquires *Self Portrait as Saint Catherine the Great of Alexandria* (c.1615–17) by Artemisia Gentileschi, the twenty-first work by a female artist in its permanent collection.

GLOSSARY

Abstract Expressionism: a movement developed by American painters in the 1940s and 1950s. The artists, such as Jackson Pollock and Willem de Kooning, were mostly based in New York. Their aspiration was to create an expressive and emotional art based on non-representational abstract forms.

Aeropittura: an aspect of Futurist painting evoking the experiences of modern life, especially flight.

Art Deco: a decorative style of the 1920s and 1930s characterized by geometric or stylized shapes based on the modernist forms of Art Nouveau.

Avant-garde: term initially used in the first half of the nineteenth century in France. In art the notion of avant-garde (meaning vanguard or advance guard) is applied to innovatory artistic practices. Exemplary avant-garde movements are Cubism and Futurism.

Blaue Reiter, Der (The Blue Rider): an artist's movement developed in Munich between 1911 and 1914, premised on abstract images and bright colours. Key members included: Wassily Kandinsky, Franz Marc, Gabriele Münter, Paul Klee and August Macke. The group's aims were outlined in *Der Blaue Reiter Almanac*, published in 1912 and edited by Kandinsky and Marc.

Bloomsbury Group: an early twentieth-century group based on the friendships between artists, writers and intellectuals who met regularly in the Bloomsbury area of London.

Baroque: refers to a style of the art, architecture and music produced in Europe between c.1600 and 1750, which involved the use of dynamism and movement, and a high degree of theatricality.

Caravaggisti: describes the artists whose style evolved from Caravaggio's use of dramatic lighting and strong chiaroscuro.

Colour Field: an abstract style of painting, in which fields of colour are applied across the canvas. Colour Field evolved in the USA from the mid-1950s to the late 1960s. The work of Ellsworth Kelly and Morris Louis is associated with this movement.

Conceptual Art: a movement emphasizing the importance of thought over form. Conceptual Art developed from the mid-1960s through the 1970s, and counts among its key exponents artists Lawrence Weiner and Joseph Kosuth.

Cubism: an approach to the representation of reality ushered in by Georges Braque and Pablo Picasso. Premised on viewing a subject or an object from multiple viewpoints at the same time, Cubism is characterized by flat abstract and fragmented planes.

Degenerate art: a term coined by the Nazis to describe the work of avant-garde artists who did not conform to the National Socialist ideology and the promotion of its values. The female artists described as degenerate were Maria Casper-Filser, Jacoba van Heemskerck, Marg Moll, Magda Nachman and Emy Roeder.

Environment art: a form of art in which the spectator is invited to enter a three-dimensional space created by the artist.

Feminist art: describes the art made by female practitioners in light of feminist ideals and theories.

Fluxus: a loose cohort of international artists active between 1962 and the early 1970s who turned to unconventional forms of art-making including Happenings, performance art and festivals.

Futurism: in 1909 with the *Manifesto of Futurism*, the Italian poet Filippo Tommaso Marinetti launched the Futurist movement. Futurists vehemently rejected the past and embraced the modern world. By the end of the First World War, Futurism had entered what is described as 'second Futurism', a phase characterized by the movement's wider impact across different fields, including design, fashion and theatre, as well as a growing interest in flight (see *Aeropittura*).

Grand Tour: in the eighteenth century many young aristocrats travelled to Italy to experience the country's cultural riches. Visits to Rome, Venice, Florence and Naples were a must. Other itineraries included France and Greece.

Happening: term coined by artist Allan Kaprow in 1959. Happenings involved the artist and possibly the spectator too in actions that were not confined to an art gallery.

History painting: concerned with the depiction of classical, mythological and biblical scenes, history painting was regarded as the highest form of painting from the Renaissance to the Neoclassical period.

Impressionism: a movement in French painting premised on sketch-like brushstrokes and concerned with the representation of modern life and landscape. The term 'Impressionism' was originally coined by the art critic Louis Leroy, who in a scathing review condemned the work of Claude Monet and his peers as being too subjective, that is, 'based on their personal impressions'.

Manifesto: a written statement outlining the objectives of a group.

Mannerism: characterizes the art made in Italy after the Renaissance and before the emergence of the Baroque. Tainted by pejorative connotations, Mannerism was considered too intricate, overly elaborate and at times unbalanced.

Neoclassicism: a classicizing style based on the study of antique art evolving in the late eighteenth and early nineteenth centuries, which embraced architecture, decorative art and visual art. The painter Jacques-Louis David and the sculptor Antonio Canova were among the style's leading figures.

Nouveau Réalisme: a French movement founded by the critic Pierre Restany in 1960 that was based on the assemblage of pre-existing objects and materials.

Omega Workshops: a co-operative of artists founded by art critic Roger Fry in 1913 dedicated to the production of household objects. Vanessa Bell was one of the community's leading artists. In 1919 the Omega Workshops were sold.

Performance art: rose to prominence in the late 1960s and 1970s. As an art form, performance art, relies on the combination of elements drawn from theatre, music and the visual arts.

Photomontage: a technique based on the cutting, arranging and pasting of pre-existing photographs to form a new composition.

Plein air: closely linked with the practice of Impressionist painters, who worked for mainly outdoors, or *en plein air* (French for open air).

Pop Art: a movement born in the late 1950s and developing through the 1960s, Pop Art drew its imagery from the worlds of advertisement, consumer culture and popular culture. The everyday was integral to Pop Art's iconography and a monumental status was given to banal objects and images.

Post-Impressionism: an umbrella term describing pictorial developments happening in the wake of and after Impressionism. The British art critic Roger Fry first coined this term on the occasion of his exhibition 'Manet and the Post-Impressionists' held at the Grafton Galleries in London in 1910.

Rococo: originating in France at the start of the eighteenth century, Rococo is most well known as a lighthearted and sensuous style. The word stems from the union of two works 'rocaille' (rockery) and 'barocco' (Baroque).

Salon: a term used to describe the annual exhibitions that took place in Paris from 1667 onwards under the patronage of the French Académie Royale de la Peinture et de Sculpture. With the establishment of independent exhibitions, like the Salon d'Automne and Salon des Indépendants the Salon, in the nineteenth and early twentieth centuries, the term gradually lost its influence.

Simultaneity: a variation on Cubism and Futurism that sees the representation of multiple moments and movements in the same picture.

Site-specific: a work of art designed for a specific site, usually outside.

Surrealism: born as a literary movement, the notion of Surrealism was first outlined by the poet André Breton in the *First Manifesto of Surrealism* (1924). Surrealism called for the suppression of control and embraced in its place automatism and access to the unconscious, which resulted in turn in the juxtaposition of unrelated images.

Young British Artists: not bound to a particular style, the term (often abbreviated to YBA) stems from the eponymous title of an exhibition held at the Saatchi Gallery in London in 1992. This was the first of a series of exhibitions featuring the work of young artists Damien Hirst, Sarah Lucas and Tracey Emin, among others.

FURTHER READING

Armstrong, Carol and Catherine de Zegher, eds, *Women artists at the millennium.* (MIT Press, Cambridge, MA/London, 2006)

Butler, Cornelia H. and Lisa Gabrielle Mark, *Wack!: Art and the Feminist Revolution.* (Museum of Contemporary Art/MIT Press, Los Angeles, CA/Cambridge, MA/London, 2007)

Butler, Cornelia H. and Alexandra Schwartz, eds, *Modern Women: Women Artists at the Museum of Modern Art* (Thames & Hudson, New York, NY/London, 2010)

Caws, Mary Ann, *Women of Bloomsbury: Virginia, Vanessa and Carrington* (Routledge, New York, NY/London, 1990)

Caws, Mary Ann, ed., *Surrealism and Women* (MIT Press, Cambridge, MA, 1991)

Chadwick, Whitney and Isabelle de Courtivron, eds, *Significant Others: Creativity & Intimate Partnership* (Thames & Hudson, London/New York, 1993)

Chapman, Caroline, *Eighteenth-century Women Artists: their Trials, Tribulations and Triumphs* (Unicorn Publishing Group, London, 2017)

Dabbs, Julia K., *Life Stories of Women Artists, 1550–1800: an Anthology* (Ashgate, Farnham, 2009)

Deepwell, Katy, ed., *Women Artists and Modernism* (Manchester University Press, Manchester, 1998)

Laurence, Madeline, ed., *Women Artists in Paris, 1850–1900* (American Federation of Arts/Yale University Press, New York, NY/New Haven, CT, 2017).

Jones, Amelia, ed., *The Feminism and Visual Culture Reader* (Routledge, London, 2010)

Malycheva, Tanja and Isabel Wünsche, eds, *Marianne Werefkin and the Women Artists in her Circle* (Brill Rodopi, Leiden/Boston, MA, 2017)

Marter, Joan, ed., *Women of abstract expressionism* (Denver Art Museum/Yale University Press, Denver, CO/New Haven, CT, 2016)

Nochlin, Linda and Ann Sutherland Harris, eds, *Women Artists, 1550–1950* (Museum of Contemporary Art, Los Angeles/Alfred A. Knopf, Los Angeles, CA/New York, NY, 1976)

Nochlin, Linda and Joelle Bolloch, eds, *Women in the 19th century: Categories and Contradictions* (New Press/Musée d'Orsay, New York, NY/Paris, 1997)

Nochlin, Linda and Maura Reilly, ed., *Global Feminisms: New Directions in Contemporary Art* (Merrell, London, 2007)

Schor, Gabriele, *The Feminist Avant-garde: Art of the 1970s: The Sammlung Verbund Collection, Vienna* (Prestel, Munich, 2016)

Zegher, Catherine de, ed., *Inside the Visible: an Eliptical Traverse of Twentieth-century Art in, of, and from the Feminine* (MIT Press, Cambridge, MA/London, 1996)

INDEX OF ARTISTS

Main entries are in **bold**, illustrations are in *italics*.

Abakanowicz, Magdalena (Polish) **116–17**, *117*

Abramović, Marina (Serbian) **142–3**, *143*

Acconci, Vito (American, 1940–2017) 143

Af Klint, Hilma (Swedish) **44–5**, *45*

Albers, Josef (German–American, 1888–1976) 121, *122*

Álvarez Bravo, Manuel (Mexican, 1902–2002) 137

Andre, Carl (American, b.1935) 144

Arp, Jean (French–German, 1886–1966) 81

Balla, Giacomo (Italian, 1871–1958) 66

Bauck, Jeanne (Swedish–German, 1840–1926) 46

Beert, Osias (Flemish, c.1580–late 1624) 16

Bell, Vanessa (English) **52–3**, *52*

Beuys, Joseph (German, 1921–86) 143

Bochner, Mel (American, b.1940) 124

Bonheur, Rosa (French) **32–3**, *32, 33*

Bonnard, Pierre (French, 1867–1947) 49, 53

Bourgeois, Louise (French–American) **86–9**, *86, 88–9*,

Brâncuşi, Constantin (French–Romanian, 1876–1957) 81

Braque, Georges (French, 1882–1963) 96

Brecht, George (American, 1926–2008) 119

Breton, André (French, 1896–1966) 82

Buñuel, Luis (Spanish, 1900–83) 100

Cage, John (American, 1912–92) 119

Cameron, Julia Margaret (English) **28–31**, *29, 30, 53*

Canova, Antonio (Italian, 1757–1822) 24

Cappa Marinetti, Benedetta (Italian) **66–9**, *67, 68*

Caravaggio (Italian, 1571–1610) 12

Carriera, Rosalba (Italian) **20–21**, *21*

Carrington, Leonora (Mexican–English) **100–1**, *101*

Cartier Bresson, Henri (French, 1908–2004) 137

Cassatt, Mary (American active in France) 34, **38–41**, *39, 41*

Cézanne, Paul (French, 1839–1906) 49

Chernysheva, Olga (Russian) **154–5**, *154, 155*

Chicago, Judy (American) **128–9**, *128*

Cieslewicz, Roman (Polish active in France, 1930–96) 108

Clough, Charles (American, b.1951) 151

Courbet, Gustave (French, 1819–77) 38

Degas, Edgar (French, 1834–1917) 34, 37, 38

De Kooning, Elaine (American, 1918–89) 111

De Kooning, Willem (Dutch active in America, 1904–97) 105

Delaunay, Robert (French, 1885–1941) 55

Delaunay, Sonia (Russian active in France) **54–5**, *54,*

De Lempicka, Tamara (American–Polish) **70–71**, *71*

Denis, Maurice (French, 1870–1943) 70

Dias, Antônio (Brazilian, 1944–2018) 134

Doyle, Tom (American, 1928–2016) 122

Emin, Tracey (English) **158–9**, *158*, 171

Énriquez, Carlos (Cuban, 1900–57) 76

Ernst, Max (German–American–French, 1891–1976) 100

Feely, Paul (American, 1910–66) 111

Fontana, Lavinia (Italian) 7, **10–11**, *11*

Fontana, Prospero (Italian, 1512–97) 10

Frank, Robert (American–Swiss, b.1924) 127

Frankenthaler, Helen (American) 105, **110–1**, *110*

Gabo, Naum (American–Belarusian, 1890–1977) 81

Gauguin, Paul (French, 1848–1903) 49

Gego (German–Venezuelan) **90–93**, *90, 92–93*,

Gentileschi, Artemisia (Italian) 9, **12–15**, *13, 15*

Gentileschi, Orazio (Italian, 1563–1639) 12

Gerchman, Rubens (Brazilian, 1942–2008) 134

Giorgione (Italian, c.1477/8–1510) 118

Giotto (Italian, c.1267/75–1337) 31

Gottlieb, Adolph (American, 1903–74) 111

Guerrilla Girls (American) 9, **164–5**, *164*

Hartigan, Grace (American, 1922–2008) 111

Hepworth, Barbara (English) **80–81**, *80*

Hesse, Eva (American–German) 88, **122–5**,

Dias, Antônio (Brazilian, 1944–2018) 134

Hicks, Sheila (American) **120–21**, *120*

Höch, Hannah (German) **60–61**, *61*

Hofmann, Hans (American–German, 1880–1966) 73

Hone, Nathaniel (Irish–English, 1718–84) 24

Iturbide, Graciela (Mexican) **136–9**, *136, 138–9*

Jawlensky, Alexej von (Russian active in Germany, 1864–1941) 50

Johns, Jasper (American, b.1930) 73

Jonas, Joan (American) **126–7**, *127*

Kahlo, Frida (Mexican) **82–3**, *83*, 138, 165

Kandinsky, Wassily (Russian, 1866–1944) 44, 50, 51

Kauffman, Angelica (Swiss) **22–5**, *22, 25, 26*

Kauffman, Johann Joseph (Swiss, 1707–82) 23

Kline, Franz (American, 1910–62) 105

Klumpke, Anna (American active in France, 1856–1942) 33

Krasner, Lee (American, c.1908/12–84) 111

Kusama, Yayoi (Japanese–American) **112–13**, *113*

Le Brun, Jean–Baptiste–Pierre (French, 1748–1813) 26

Le Fauconnier, Henri (French, 1881–1946) 63

LeWitt, Sol (American, 1928–2007) 122

Lhote, André (French, 1885–1962) 70

Longo, Robert (American, b.1953) 151

Louis, Morris (American, 1912–62) 111

Lucas, Sarah (British b.1962) 171

Maciunas, George (American, 1931–78) 119
Macke, August (German, 1887–1914) 50
Mackensen, Fritz (German, 1866–1953) 46
Maiolino, Anna Maria (Brazilian–Italian) **134–5**, *134*, *135*
Malevich, Kasimir (Russian–Ukrainian, 1878–1935) 44, 63
Manet, Édouard (French, 1832–1883) 37, 38, 118, 161
Marc, Franz (German, 1880–1916) 50
Marinetti, Filippo Tommaso (Italian, 1876–1944) 66, 69
Martin, Agnes (American–Canadian) **94–5**, *95*
Martin, Sadie (English, 1906–92) 81
Matisse, Henri (French, 1869–1954) 53, 96
Mendieta, Ana (American–Cuban) **144–7**, *145*, *146–7*
Michelangelo (Italian, c.1475–1564) 31
Millais, John Everett (English, 1829–96) 31
Mitchell, Joan (American active in France) **104–5**, *104*, 111
Modersohn, Otto (German, 1865–1943) 46, 49
Modersohn–Becker, Paula (German) **46–9**, *47*, *48*, 165
Modotti, Tina (Italian active in Mexico) **64–5**, *64*, *65*
Monet, Claude (French, 1840–1926) 34, 37
Moore, Henry (English, 1898–1986) 81
Morisot, Berthe (French) **34–7**, *35*, *36*, 40
Morris, Robert (American,

b.1931) 122, 124
Moser, Mary (English, 1744–1819) 23
Motherwell, Robert (American, 1915–91) 111
Münter, Gabriele (German, 1877–1962) **50–51**, *51*

Nauman, Bruce (American, b.1941) 88
Neel, Alice (American) **76–9**, *77*, *78*
Nevelson, Louise (Ukranian–American) **72–3**, *72*
Nicholson, Ben (English, 1894–1982) 81
Noland, Kenneth (American, 1924–2010) 111

O'Keeffe, Georgia (American) **56–9**, *57*, *58*, 94, 112, 129
Ono, Yoko (Japanese) **118–19**, *119*
Ozenfant, Amédée (French, 1886–1996) 100

Parmigianino (Italian, 1503–40) 10
Peeters, Clara (Flemish) 7, **16–19**, *17*, *18–19*
Pica, Amalia (Argentinian) **162–3**, *163*
Picasso, Pablo (Spanish active in France, 1881–1973) 53, 96
Pissarro, Camille (French, 1830–1903) 37
Pollock, Jackson (American, 1912–56) 105
Popova, Lyubov (Russian) **62–3**, *62*

Rama, Carol (Italian) **102–3**, *103*
Raphael (Italian, 1483–1520) 10, 31
Rauschenberg, Robert (American, 1925–2008) 73
Renoir, Auguste (French, 1841–1919) 34, 37

Reynolds, Joshua (English, 1723–92) 23, 24
Riopelle, Jean–Paul (Canadian, 1923–2002) 105
Rivera, Diego (Mexican, 1886–1957) 82
Rodin, Auguste (French, 1840–1917) 49
Rosler, Martha (American) **140–41**, *140*
Rossetti, Gabriel Dante (English, 1828–82) 31
Ryman, Robert (American, b.1930) 122

Saint Phalle, Niki de (French) **114–15**, *114*
Schapiro, Miriam (American–Canadian, 1923–2015) 129
Schneemann, Carolee (American) **130–31**, *131*
Sher-Gil, Amrita (Indian–Hungarian) **96–9**, *97*, *98*
Sherman, Cindy (American) **146–9**, *147*, *160*
Sisley, Alfred (English–French, 1839–99) 37
Skeaping, John (English, 1901–80) 81
Smithson, Robert (American, 1938–73) 122
Stiattesi, Pietro (Italian) 12
Stieglitz, Alfred (American, 1864–1946) 56
Szapocznikow, Alina (Polish) **108–9**, *109*
Szenès, Árpád (Hungarian active in France, 1897–1984) 84

Tamayo, Rufino (Mexican, 1899–1991) 111
Tassi, Agostino (Italian, c.1580–1644) 12
Tatlin, Vladimir (Ukrainian active in Russia, 1885–1953) 63
Tinguely, Jean (Swiss, 1925–91) 115

Ulay (German, b.1943) 142
Ultvedt, Per Olof (Finnish, b.1927) 115

Varo, Remedios (Spanish active in Mexico, 1908–63) 100
Vergara, Carlos (Brazilian, b.1941) 134
Vieira da Silva, Maria Helena (French–Portuguese) **84–5**, *85*
Vigée Le Brun, Élisabeth–Louise (French) **26–7**, *27*
Vogeler, Heinrich (German, 1872–1942) 46

Warhol, Andy (American, 1928–87) 79
Watteau, Jean–Antoine (French, 1684–1721) 20
Weston, Edward (American, 1886–1958) 64, 65
Werefkin, Marianne von (Russian, c.1860/70–1938) 50
Whiteread, Rachel (English) **156–7**, *157*
Whistler, James (Abbott) McNeill (American, 1834–1903) 161
Woodman, Francesca (American) **150–53**, *153*, *155*

Yiadom–Boakye, Lynette (English) **160–61**, *160*, *161*
Young, La Monte (American, b.1935) 119

Zappi, Paolo (Italian) 11
Zhukovsky, Stanislav (Russian, 1873–1944) 63
Zucchi, Antonio (Italian, 1726–95) 23

PICTURE ACKNOWLEDGEMENTS

Page 2 Courtesy Ota Fine Arts, Tokyo/Singapore/Shanghai and Victoria Miro, London/Venice. © Yayoi Kusama; **8** Los Angeles County Museum of Art. Mrs Fred Hathaway Bixby Bequest, M.62.8.14; **11** Private collection; **13** Schloss Weissenstein, Schönbornsche Kunstsammlungen, Pommersfelden; **15** Royal Collection; **17** National Museum of Women in the Arts, Washington, DC Gift of Wallace and Wilhelmina Holladay. Photo The Picture Art Collection/Alamy Stock Photo; **18–19** Museo del Prado, Madrid; **21** The J. Paul Getty Museum, Los Angeles; **22** National Portrait Gallery, London; **25** Collection Royal Academy of Arts. Acquisition Commissioned from Angelica Kauffman RA in 1778-1780 (03/1129). Photo John Hammond/Royal Academy of Arts, London; **27** Museum of Fine Arts, St. Petersburg, Florida. Rexford Stead Art Purchase Fund; **29, 30** The J. Paul Getty Museum, Los Angeles; **32** Musée d'Orsay, Paris; **33** Wallace Collection, London. Photo Art Collection 3/Alamy Stock Photo; **35** Musée d'Orsay, Paris; **36** The Metropolitan Museum of Art. Partial and Promised Gift of Mr. and Mrs Douglas Dillon, 1992, 1992.103.2; **39** Los Angeles County Museum of Art. Mrs Fred Hathaway Bixby Bequest, M.62.8.14; **41** National Gallery of Art, Washington, DC, Chester Dale Collection, 1963.10.95; **42** Palazzo delle Poste, Palermo. Courtesy Archivio Storico di Poste Italiane. Photo AGR/Riccardi/Paoloni. © Benedetta Cappa Marinetti, used by permission of Vittoria Marinetti and Luce Marinetti's heirs; **45** Hilma af Klint Foundation, Stockholm; **47** Freie Hansestadt, Bremen. Photo Art Collection 3/Alamy Stock Photo; **48** Freie Hansestadt, Bremen; **51** Städtische Galerie im Lenbachhaus, München. © DACS 2019; **52** National Portrait Gallery, London. Purchased with help from the Dame Helen Gardner Bequest, 2005. © The Estate of Vanessa Bell courtesy of Henrietta Garnett; **54** Museo Nacional Thyssen-Bornemisza/Scala, Florence. © Pracusa 2018650; **57** Crystal Bridges Museum of American Art, Bentonville, Arkansas. © Georgia O'Keeffe Museum/DACS 2019; **58** The Metropolitan Museum of Art, New York. Alfred Stieglitz Collection, 1959, 59.204.2/Art Resource/Scala, Florence. © 2018 The Metropolitan Museum of Art; **61** Nationalgalerie, Staatliche Museen zu Berlin, Berlin. © DACS 2019; **62** Los Angeles County Museum of Art. Purchased with funds provided by the Estate of Hans G. M. de Schulthess and the David E. Bright Bequest, 87.4; **64, 65** The J. Paul Getty Museum, Los Angeles; **67, 68** Palazzo delle Poste, Palermo. Courtesy Archivio Storico di Poste Italiane. Photo AGR/Riccardi/Paoloni. © Benedetta Cappa Marinetti, used by permission of Vittoria Marinetti and Luce Marinetti's heirs; **71** Musée des Beaux-Arts de Nantes. Photo RMN-Grand Palais/Gérard Blot. © Tamara Art Heritage/ADAGP, Paris and DACS London 2019; **72** Photo Gordon R. Christmas, courtesy Pace Gallery. © ARS, NY and DACS, London 2019; **74** Private collection, Turin. Photo Pino dell'Aquila. © Archivio Carol Rama, Turin; **77** Whitney Museum of American Art, New York. Gift of Timothy Collin. © The Estate of Alice Neel, courtesy David Zwirner, New York/London; **78** Museum of Fine Arts, Boston. © The Estate of Alice Neel, courtesy David Zwirner, New York/London; **80** Yale Center for British Art, Gift of Virginia Vogel Mattern in memory of her husband, W. Gray Mattern, Yale College, Yale BA 1946. © Bowness; **83** Collection of the Albright-Knox Art Gallery, Buffalo, New York. Bequest of A. Conger Goodyear, 1966. © Banco de México Diego Rivera Frida Kahlo Museums Trust, Mexico, D.F./DACS; **85** Calouste Gulbenkian Foundation, Lisbon. Calouste Gulbenkian Museum – Modern Collection. Photo Paulo Costa. © ADAGP, Paris and DACS, London 2019; **86** Collection Glenstone Museum, Potomac, Maryland. Photo Maximilian Geuter. © The Easton Foundation/DACS, London/VAGA, NY 2019; **88–9** Private collection. Photo Simon Lane/Alamy Stock Photo. © The Easton Foundation/DACS, London/VAGA, NY 2019; **91** Installation at the Museo de Bellas Artes, Caracas, Venezuela. Fundación de Museos Nacionales Collection. Photo Paolo Gasparini. © Fundación Gego; **92** Photo Claudia Garcés. © Fundación Gego; **95** Solomon R. Guggenheim Museum, New York, Gift, Andrew Powie Fuller and Geraldine Spreckels Fuller Collection, 1999. © Agnes Martin/ DACS 2019; **97** Collection of Navina and Vivan Sundaram. Photo The Picture Art Collection/Alamy Stock Photo; **98** National Gallery of Modern Art, New Delhi. Photo The Picture Art Collection/Alamy Stock Photo; **101** The Metropolitan Museum of Art, New York. The Pierre and Maria-Gaetana Matisse Collection, 2002, 2002.456.1/Art Resource/Scala, Florence © Estate of Leonora Carrington/ARS, NY and DACS, London 2019; **103** Private Collection, Turin. Photo Pino dell'Aquila. © Archivio Carol Rama, Turin; **104** Collection of the Joan Mitchell Foundation, New York. © Estate of Joan Mitchell; **106** Helen Frankenthaler Foundation, New York, on extended loan to the National Gallery of Art, Washington, DC © Helen Frankenthaler Foundation, Inc./ARS, NY and DACS, London 2019; **109** © ADAGP, Paris. Courtesy The Estate of Alina Szapocznikow/Piotr Stanislawski/Galerie Loevenbruck, Paris/Hauser & Wirth. Photo Fabrice Gousset, courtesy Loevenbruck, Paris; **110** Helen Frankenthaler Foundation, New York, on extended loan to the National Gallery of Art, Washington, DC © Helen Frankenthaler Foundation, Inc./ARS, NY and DACS, London 2019; **113** Courtesy Ota Fine Arts, Tokyo/Singapore/Shanghai and Victoria Miro, London/Venice. © Yayoi Kusama; **114** Museum of Modern Art, New York. Gift of the Niki Charitable Art Foundation, 860.2011. © Niki de Saint Phalle Charitable Art Foundation/ADAGP, Paris and DACS, London 2019; **117** Cytadela Park, Poznań, Poland. Photo Sherab/Alamy Stock Photo. © The Estate of Magdalena Abakanowicz, courtesy Marlborough Gallery; **119** Courtesy Galerie Lelong & Co., New York. © Yoko Ono; **120** Courtesy Sikkema Jenkins & Co. New York. Photo Andrea Avezzù. © Sheila Hicks; **123** Leeum, Samsung Museum of Art, Seoul. Courtesy Hauser & Wirth. © The Estate of Eva Hesse; **125** The Art Institute of Chicago, gift of Arthur Keating and Mr. and Mrs Edward Morris by exchange, April 1988. Photo Susan Einstein. Courtesy Hauser & Wirth. © The Estate of Eva Hesse; **127** Photo Joan Jonas. Courtesy the Artist and Raffaella Cortese Gallery, Milan. © ARS, NY and DACS, London, 2019; **128** Brooklyn Museum, Gift of the Elizabeth A. Sackler Foundation, 2002.10. © Judy Chicago. ARS, NY and DACS, London 2019; **131** © Carolee Schneemann; **132** Photo Andy Keate. Courtesy Herald St, London; **134** Courtesy the artist and Hauser & Wirth. © Anna Maria Maiolino; **135** Courtesy the artist and Hauser & Wirth. Photo Stefan Altenburger Photography Zürich. © Anna Maria Maiolino; **136, 138–9** Courtesy ROSEGALLERY, Santa Monica, CA. © Graciela Iturbide; **140** Courtesy Electronic Arts Intermix, New York; **143** Museum of Modern Art, New York, 2010. Photo Marco Anelli. Courtesy the Marina Abramović Archives. © Marina Abramović. Courtesy of Marina Abramović and Sean Kelly Gallery, New York. DACS 2019; **145** Courtesy Galerie Lelong & Co., New York, (GL2225). © The Estate of Ana Mendieta, LLC; **147, 148** Courtesy the artist and Metro Pictures, New York; **151, 153** Courtesy Charles Woodman and Victoria Miro Gallery, London. © Courtesy Charles Woodman; **154, 155** Private collection, London. Courtesy Matthew Stephenson, London; **157** National Gallery of Art, Washington, DC Gift of The Glenstone Foundation, 2004.121.1. Courtesy the artist and Gagosian. Photo Mike Bruce. © Rachel Whiteread; **158** © Tracey Emin. All rights reserved, DACS/Artimage 2018. Image courtesy Saatchi Gallery, London. Photo Prudence Cuming Associates Ltd; **160, 161** Courtesy the artist, Corvi-Mora, London and Jack Shainman Gallery, New York; **163** Photo Andy Keate. Courtesy Herald St, London; **164** © Guerrilla Girls, courtesy guerrillagirls.com

-

To Cinzia and Gloria, who showed me how to be a woman and a feminist

-

Women Artists © 2019
Thames & Hudson Ltd, London
Text © 2019 Flavia Frigeri

Design by April
Edited by Caroline Brooke Johnson
Picture Research by Maria Ranauro

First published in 2019 in the
United States by Thames & Hudson
Inc., 500 Fifth Avenue, New York,
New York 10110

www.thamesandhudsonusa.com

Library of Congress Control
Number 2018945307
ISBN 978-0-500-29435-2

Printed and bound in China

Front cover: Cindy Sherman, *Untitled Film Still #21*, 1978. Courtesy the artist and Metro Pictures, New York (detail of page 147)

Title page: Yayoi Kusama, *Infinity Mirrored Room – Filled with the Brilliance of Life*, 2011 (detail of page 113). Courtesy Ota Fine Arts, Tokyo/Singapore/Shanghai and Victoria Miro, London/Venice. © Yayoi Kusama

Chapter openers: page 8 Mary Cassatt, *Mother about to Wash her Sleepy Child*, 1880, Los Angeles County Museum of Art, Los Angeles, CA (detail of page 39); **page 42** Benedetta Cappa Marinetti, *Synthesis of Radio Communications* (detail), 1933–4, Palazzo delle Poste, Palermo. Courtesy Archivio Storico di Poste Italiane. Photo AGR/Riccardi/Paoloni. © Benedetta Cappa Marinetti, used with permission of Vittoria Marinetti and Luce Marinetti's heirs; **page 74** Carol Rama, *Appassionata*, 1943, Private collection, Turin (detail of page 103); **page 106** Helen Frankenthaler, *Mountains and Sea*, 1952, Helen Frankenthaler Foundation, New York (detail of page 110); **page 132** Amalia Pica, *A∩B∩ C*, 2013, courtesy the artist and Hauser & Wirth (detail of page 163)

Quotations: page 9 Ann Sutherland Harris and Linda Nochlin, *Women Artists, 1550-1950* (New York 1976), p.120; **page 42** William B. Breuer and Fereydoun Hoveyda, *War and American Women: Heroism, Deeds, and Controversy* (London 1997), p.14; **page 75** Lucy Lippard, *From the Center: Feminist Essays on Women's Art* (New York 1976), p.139; **page 107** Joan Marter (ed.), *Women of Abstract Expressionism* (New Haven 2016), p.160; **page 133** Martha Rosler, 'Art and Everyday Life', lecture at the Lisbon Summer School for the Study of Culture, 2014. Accessed 5 October 2018: https://lisbonconsortium.com/summer-school/iv-lisbon-summer-school-for-the-study-of-culture/